the photographer's guide to the
Colorado Rockies

Where to Find Perfect Shots and How to Take Them

Don Mammoser

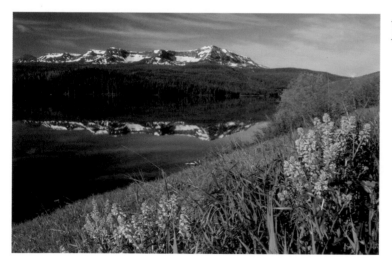

THE COUNTRYMAN PRESS
WOODSTOCK, VERMONT

ISBN 978-0-88150-733-1

Cover and interior photographs by the author unless otherwise indicated
Cover and interior design by S.E. Livingston
Maps by Paul Woodward, © The Countryman Press

Published by The Countryman Press, P.O. Box 748, Woodstock, VT 05091
Distributed by W.W. Norton & Company, Inc. 500 Fifth Avenue, New York, NY 10110

Printed in China

10 9 8 7 6 5 4 3 2 1

Frontispiece: Flat Tops Wilderness; Facing Page: Forest Road 667

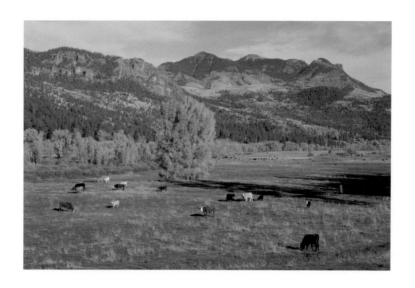

To my mother and in loving memory of my father,
who first taught me the wonders of nature.

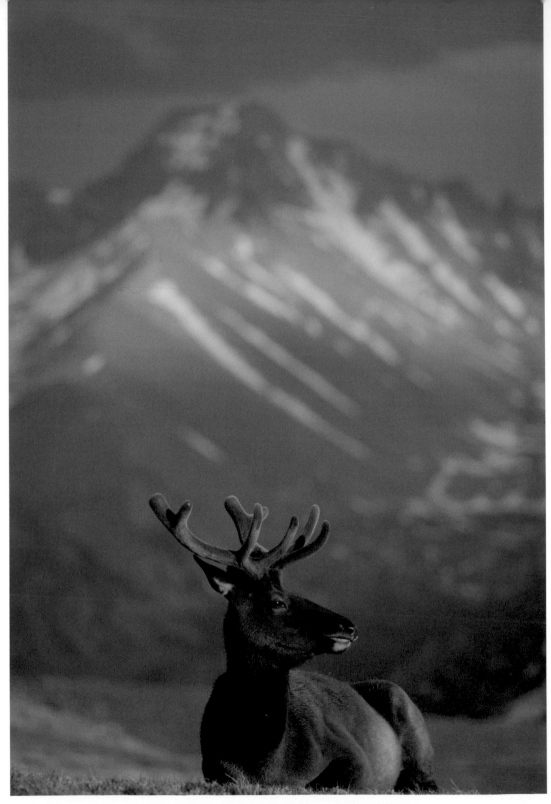

Elk and Longs Peak, Rocky Mountain National Park

Contents

Introduction .7
Using This Book .8
How I Photograph the Colorado Rockies9

I. Northern Colorado Rockies

Rocky Mountain National Park Area15
 1. Moraine Park Area/Cub Lake Trail15
 2. Sprague Lake .16
 3. Bear Lake and Dream Lake Trails17
 4. Fall River Road .17
 5. Trail Ridge Road, Hidden Valley to
 Medicine Bow Curve18
 6. Lily Lake Area .19
 7. Wild Basin Area20
 8. Kawuneeche Valley21
 9. Twin Owls/MacGregor Ranch21
 10. Estes Park/Stanley Hotel Area22

Lake Granby Area23
 11. Stillwater Area .24
 12. Grand Lake .24
 13. Arapaho Bay .25
 14. Green Ridge Area/Continental Divide
 Trail .25

State Forest State Park Area26
 15. Cameron Pass .27
 16. Nokhu Crags/Lake Agnes27
 17. North Michigan Creek Reservoir28
 18. North Shore Road28

Steamboat Springs Area29
 19. Muddy Pass and Rabbit Ears Pass29
 20. Fish Creek Trail and Falls30
 21. Steamboat Springs Town and
 Ski Resort .30
 22. Pearl Lake State Park31
 23. Steamboat Lake State Park32
 24. Hahn's Peak Lake32

CO 14 through Poudre Canyon33
 25. Picnic Rock State Park34
 26. Poudre Park Picnic Area34
 27. Mountain Park/Narrows Area34

 28. Profile Rock to Poudre Falls35
 29. Chambers Lake and Lost Lake35

II. Along the I-70 Corridor

Mount Evans Area37
 30. CO 103 from I-70 to Echo Lake Park . . .38
 31. Mount Goliath Natural Area38
 32. Summit Lake Area38
 33. Top of Mount Evans39

CO 119, Nederland to US 640
 34. "Oh My God" Road41
 35. Golden Gate Canyon State Park41

Denver Foothills .42
 36. Red Rocks Park42
 37. Roxborough State Park43

**I-70, Georgetown to Glenwood
Springs** .44
 38. Georgetown Loop Railroad44
 39. Georgetown Bighorn Viewing Area45
 40. Guanella Pass Road45
 41. Loveland Pass .46
 42. Dillon Reservoir47
 43. Breckenridge .48
 44. Shrine Pass .49
 45. Hanging Lake .50
 46. Glenwood Canyon51

III. Central Colorado Rockies

Aspen Area .53
 47. Aspen Town and Ski Areas53
 48. Maroon Bells .54
 49. Ashcroft Ghost Town55
 50. Independence Pass Road55
 51. McClure Pass .57

Colorado Springs Area58
 52. Pikes Peak .58
 53. Garden of the Gods59
 54. Mueller State Park59

Crested Butte Area60
 55. Gothic Road .60

56. Paradise Basin and Pass Road61
57. Lake Irwin .62
58. Forest Road 730/Ohio Pass52
59. Forest Road 738 .63
60. Curecanti National Recreation Area63
61. Black Canyon of the
 Gunnison National Park64

US 24, Tennessee Pass to Buena Vista .65
62. Tennessee Pass .65
63. Turquoise Lake .66
64. Mount Elbert/Twin Lakes Area66
65. Along the Arkansas River67
66. Cottonwood Pass .68
67. Forest Road 344 .69

IV. South-Central Rockies

US 160, Walsenburg to Pagosa Springs .71
68. Old La Veta Pass .71
69. Blanca Peak .72
70. Alamosa National Wildlife Refuge72
71. Great Sand Dunes National Park73
72. Monte Vista National Wildlife Refuge . . .73
73. San Luis Lake State Park74
74. North Clear Creek Falls74
75. Wolf Creek Pass .75
76. Treasure Falls .76
77. Forest Road 667 .76

Scenic Highway of Legends (CO 12)77
78. Monument Lake .77
79. Cucharas and Cordova Passes77
80. Spanish Peaks .78

V. South-Western Rockies

Ouray to Telluride79
81. Town of Ouray .79
82. Ouray Ice-Climbing Area81
83. Yankee Boy Basin82
84. East Dallas Creek Road82
85. Dallas Divide .83
86. Town of Telluride83
87. Last Dollar Road .84
88. Alta Lakes Road .85

89. Trout Lake Area .85
90. Dunton Road (Forest Road 535)86
91. Dunton Ghost Town86

US 550, Ouray to Durango88
92. First Ten Miles Outside
 Ouray/Crystal Lake88
93. Red Mountain Pass89
94. Town of Silverton90
95. Near Molas Pass .90
96. Old Lime Creek Road91
97. Hermosa Creek Road92

Durango Area .93
98. Durango & Silverton
 Narrow Gauge Railroad93
99. La Plata River Road94
100. Mesa Verde National Park95

Near Dallas Divide

Introduction

The Rocky Mountains of Colorado have inspired poets, writers, artists, and photographers for centuries. They certainly worked their magic on me. The first time I saw Colorado's snowcapped peaks radiating beauty below an impossibly blue sky, I knew I'd found what I'd been looking for. Now, from my home in the foothills west of Denver, I enjoy mountains in all directions. To me, the Colorado Rockies mean home.

Surely, the Colorado Rockies mean different things to different people, but the word "mountain" and its derivatives probably lead the way. Colorado does indeed have lots of mountains. Rocky Mountain National Park alone has more than a hundred peaks of 10,000 feet or higher. In fact, more than 75 percent of the land over 10,000 feet high in the continental United States lies in Colorado. The state is also home to 54, 55, or 56 (depending on your source) mountain peaks that rise to more than 14,000 feet. Called "fourteeners" by those in the know, these peaks provide all sorts of recreational opportunities. All those mountains also mean lots of grand landscapes and pristine scenery to point your camera at.

But there's much more to the Colorado Rockies than lofty peaks. Potential photo subjects include mountain wildlife of all sizes, clear mountain streams, gushing waterfalls, fields of mountain flowers, frost-covered aspen leaves, snow piled up-to-here, old barns, working ranches and farms, horses, large and small mountain lakes, ghost towns, and people participating in mountain-based adrenaline ad-

Lizard Head Wilderness from Last Dollar Road

ventures. The mountains do influence almost everything that you might point a camera at here in Colorado. And that's a good thing.

A photographer wishing to capture some of the magic of the Colorado Rockies might be overwhelmed by all the wonders of this place. That's where this photographer's guide comes in. Armed with either your trusty film camera or one of the newest digital wonders and this book, you will get to the right locations at the right time for some extraordinary photos.

Sunset from Mount Evans

Using This Book

In this book I've divided the Colorado Rockies into five large sections and then chosen what I feel are the most interesting or intriguing locations that a photographer might visit in each sector. It's important to note that my interpretation of the best places for photography in the Colorado Rockies is just that—my interpretation. Some might not include certain places I've listed, or they'd add other places I've omitted. Fine. Differing opinions make life interesting; when you write your book you can include everything you want.

Have I listed *all* the photogenic places in Colorado's Rockies? Far from it. That's well beyond the scope of a book like this and might take a lifetime to compile. A good photographer can find good photos anywhere, and an intrepid adventurer might find thousands of photogenic locations that I didn't list. What I did write about are Colorado's beautiful spots —some well known, others not—that can be reached relatively easily: most by passenger car and a short hike. Although I encourage it and certainly do it myself, getting off-road isn't always practical. Not everyone wants to backpack 20 miles into the backcountry or has access to a high-clearance jeep to get "way back" for a photo. Instead, just get yourself "out there," with this book as a catalyst; as you

explore Colorado's Rockies, you're sure to discover something just over the next hill from my suggestions.

When using this guide, please note that many sites have limited or no access during some of the year. And seasons in Colorado's Rockies most definitely don't follow what your calendar says. Usually winter lasts well into May in most places here, and deep, impenetrable snow might stick around all year in other places, blocking access. The highway department doesn't even attempt to plow some of the higher passes and mountain roads in Colorado's Rockies. I've noted this type of important information in the "seasonal influences" sections. (Forgive me for any omissions or mistakes.)

Finally, I'd like to mention high-altitude safety. In many of Colorado's scenic locations you may be well above any altitude that you've ever experienced before. High elevation means less oxygen, more intense and damaging ultraviolet rays from the sun, and unpredictable and possibly dangerous weather that changes quickly (I've been snowed on more than once here in mid-July). At higher elevations you should be careful not to overexert yourself and to watch for signs of altitude sickness—shortness of breath, dizziness, headaches, and nausea. It helps to drink lots of water and to limit your caffeine and alcohol intake. If symptoms persist, get to a lower elevation; if symptoms are severe, seek medical attention. Play it safe so that you can visit and photograph more of the beautiful places that the Colorado Rockies have to offer.

Now, grab a decent Colorado map, load up your camera with film or memory cards, and explore Colorado's Rockies!

How I Photograph the Colorado Rockies

Equipment

I've been teaching photography classes and leading photo workshops for a long time now, and I often get students who are obsessed with finding the "secret" piece of gear or "magic" filter that the pros use to get great shots. In response, I sometimes show examples of photos I've taken with low-end point-and-shoot cameras, no filters and no special gear. Usually these same students are impressed with the shots but still have difficulty believing that the person holding the camera makes great photos, and that the equipment does not.

Before I talk about equipment, I just want to relay the fact that all the newest, latest, most expensive camera stuff won't get you great photos. A keen eye, location or subject knowledge, some research, lots of hard work, and plenty of patience are much more important to that end. However, photography by its very nature *is* equipment oriented, and you could easily empty your bank account on things you don't need, so I'll briefly cover the basics here.

Digital and Film: Without going into a long and heated discourse about which is better, apples or oranges, I'll just say that both methods of photography are legitimate ways to put your creative vision onto paper and then onto your wall (or photo album, scrapbook, magazine, book, or wherever). Digital photography has caused a resurgence in photography in general. Lots of people who were fed up with not knowing if they got the shot until it was too late, are now shooting pictures again—and this is a good thing, and one reason why I'm glad digital photography came along. The pictures in this book are about half film and half digital. The film shots (only I know which ones) are slides from my files and were scanned for the book; some of them I took before digital photography even existed. I now shoot 95 percent of my professional work digitally. The other 5 percent is done with a medium-format camera and slide film. Whichever way you capture images, just do your best and pay no attention to the other guy's camera type.

SLR and PHD Cameras: These are the two main types of cameras and both are available as film or as digital. The SLR is a Single Lens Reflex camera. Many things define an SLR but the overriding one is that this type of camera has interchangeable lenses. You can snap one lens on for wide-angle scenics and a totally different lens might be used for wildlife. The best feature of an SLR camera is that there are no limitations. If you can imagine something you want to do photographically, an SLR body coupled with the right lens can help you achieve that shot. Most professional photographers use an SLR system at least (in my case) some of the time.

A PHD camera is a "Push Here Dummy" camera. And I in no way mean to belittle or deride this type of camera—PHD is just my cute

Sandhill crane

way of referring to it. Indeed I have several of these, all digital, and I have used them for magazine assignments and for some of the photos in this book, and have even written complete articles about how much I love these little do-it-alls. PHD cameras are a complete package in a compact form. Some of the latest digital PHDs have extremely long zooms, image stabilization technology, and lots of useful functions. Best of all, these cameras are lightweight and easy to carry, so you can always have a camera with you. Used properly, these cameras will give you amazing results.

Tripods: If you're not happy with the pictures you are getting, if something just seems wrong, the one-word answer to your problems usually is a tripod, in my experience. I know, I know, these three-legged monsters are heavy, bulky, and time consuming to set up and use. And there are some instances where a tripod prevents you from doing what you want to do. Incognito street shooting, skiing shots, and certain fast-moving wildlife situations are times when even I would leave my tripod behind. But for the vast majority of other outdoor and nature photography, a tripod will improve your shots more than any other piece of equipment you can buy. The reason I espouse tripods so much and why I used a big, heavy, full-size one for 99 percent of the shots in this book, is that they slow you down. They force you to think about and compose your shots carefully. They give you time to look at all your frame edges, to level the horizon, and to work at making images rather than just taking snapshots. To improve every picture you take from now on, slow down and attach your camera to the heaviest tripod you can comfortably carry.

Filters: There are no "magic" filters that make the light look amazing. Good light on the landscape is good light and usually doesn't need any filter of any type to improve it. I do use a

No polarizing filter

few filters that help me capture the light that I can see, but that the film or digital sensor can't replicate alone. When shooting film, I use warming filters (an 81b generally) to eliminate the blue light reflected from a blue sky that shows up in open shade, water, or snow scenes. When shooting digitally under these conditions, a change in white balance does the same thing as a warming filter.

A split neutral density filter (square or rectangular in shape, dark at the top, clear at the bottom) helps control the overall contrast in many mountain scenes, especially at the magic hours of dawn and dusk. Digital shooters can use a split neutral density filter or another technique I describe in "Computers and Photo Software" below. When I use one of these filters, I just hold it in front of my lens with my fingers.

A polarizer is the filter I use most often. This filter screws on the front of the lens and has two

With polarizing filter

glass pieces that rotate on top of each other. It helps make dull skies a bit bluer and increases the contrast between clouds and sky. Improving skies is fine but I most often use a polarizer to cut out what I call white-light reflections. These are the little reflections on wet leaves, the sheen on a body of water, and the bright spots you'll see on wet rocks. When you eliminate these reflections with a polarizer, the actual colors of the subject show through. The result is a better photo.

Other Gadgets: I try to carry as little as possible, especially on trips into the backcountry, when hiking, or when traveling by airplane. As I said before, don't get bogged down with too much photographic stuff—it won't necessarily make your photos better. I do carry some gadgets, however; three that make my photographic life easier are a Plamp, a diffuser, and a digital wallet.

The Plamp is a handy little device for close-up work. It is basically an adjustable arm with small clamps on both ends. One clamp holds onto a long flower stalk (or whatever needs steadying in the wind) and the other end clamps to a small tree or your tripod. The result is a sharp photo because the Plamp holds your small subject steady. The Plamp (short for "plant clamp") is made by Wimberley (www.tripodhead.com).

A diffuser is a disc that I use to throw a shadow onto close-up subjects on sunny days. Most delicate subjects, particularly wildflowers, look much nicer if they are not being lit by harsh, direct sunlight. A diffuser held close to a flower will cast just enough shadow. It folds up into a nice small circle for ease of carrying and pops open into a much larger circle for use. I often use my Plamp to hold my diffuser.

A digital wallet is my best friend for digital peace of mind. This little gadget (about double the size of a deck of cards) is used for downloading my digital images while I'm in the field. Much easier (and more durable) to carry than a laptop, it allows me to store and transport thousands of images safely until I get home to my computer. I use one made by Wolverine that has 40GB of storage space (www.wolverinedata.com).

Composition and Light

Composition is combining elements that exist in reality into an image—or deciding what not to show—to form a complete picture that makes sense visually. Countless books are available on this subject, so I will offer just a few highlights here.

One of the biggies of composition has to do with placement of subjects within your frame. The middle is not where you want to place your main subject—usually. If you don't know where the main subject should be, divide your

Using guideline of thirds

frame into a tic-tac-toe board. You can do this mentally or with on-demand grid lines in some cameras. Any junction of two intersecting lines is called a "power point" and is a good place to put the subject of your photo. This is known as the "guideline of thirds." Offsetting the subject creates a pleasing imbalance to your photos and makes your shots visually interesting. Offsetting the horizon is a good idea also.

Light is also a photographic subject that has been explored and discussed deeply—and rightly so. Great light can make even mundane subjects look breathtaking in photos. Conversely, dull light can make the most amazing subject (think the Grand Canyon photographed at midday), well, dull. Outdoor photographers know that the best light is usually seen in nature when the sun is at a low angle in the sky. This means getting up early for sunrises and staying out late for sunsets.

The quality of the light striking your subject has to do with many things. One factor is where that light is coming from: the direction of the light. The extremes of directional light are front, back, and side lighting. Front light is when the sun is over the photographer's shoulder and is hitting the front of the subject. Front lighting is fine for certain subjects (it is my favorite light for flying birds) but is not, contrary to popular belief, the only light a photographer should use. Back lighting is when the sun hits the back of your subject and you are shooting into the sun. This is by far the most dramatic lighting a photographer can get. Side light is just what it sounds like: the sun is striking the side of your subject. This is the best light to emphasize shadows and give a three-dimensional feel to your photos. On certain subjects, such as flowers, you the photographer can move around and get back, front, or side light as you wish.

A fourth type of light is what I call cloudy-light. This is the light on the land when clouds cover the sun. This is omnidirectional or directionless light. There are no shadows on a cloudy day, and the light is soft and diffused. I love this light—for certain subjects. If clouds move in and cover the sun in the Colorado Rockies, I immediately look to photograph soft delicate subjects. Wildflowers, forest scenes, streams, waterfalls, and even certain wildlife all look good under this type of light.

Last topic under this section is that big beautiful Colorado sky. I refer often throughout the site write-ups to the sky. Ask yourself what type of sky you have. A "good sky" is one that holds interest with puffy white clouds mixed in with deep blue, or maybe a cloud bank that catches nice color at sunrise. A "bad sky" is a boring sky. Huge, nothing-but-blue (or, as my friend David Middleton calls it, "screaming blue") skies are quite boring. Completely overcast white or gray skies are also boring. If you have good sky, show it by offsetting your horizon toward the bottom. If you have bad sky because of too much blue, emphasize the foreground by offsetting your horizon toward the top. If you have bad sky because of too much white, get out there and photograph some of the delicate subjects described above.

Computers and Photo Software

Back when I shot only film, I spent lots of time at my light table and a little time at the computer. Now with digital photography, I rely on the computer constantly (and rarely use my light table). I am by no means a computer or technical expert and rely on my wonderful wife, Shelly, to help me get out of trouble in this area. However, I do have advice on several technical issues for photographers.

After a session of shooting digital images, backed up in the field on my Wolverine digital wallet, I download them to my desktop computer in my office. All images are also stored off the computer and on external hard drives that are set up in a RAID system (a mirror-image computer array for safety in case one drive crashes). I also frequently burn digital images to DVDs for archiving in a secure location. The software I use for organizing all those digital images is called Portfolio, made by Extensis (www.extensis.com). Google also offers a great photo-organizing product called Picasa, a free download (www.picasa.google.com).

When it comes to outputting photos—making prints, that is—I could fill several volumes about this topic, but here I'll give you a few rules to live by. The most widespread image manipulation software is Adobe Photoshop; the latest version as of this writing is CS3. I use this software, but I try very hard not to. Let me explain. As a photographer I have no desire to spend any more time in front of my computer than I already do. I'd much rather be outside taking pictures. When I'm "out there" I try to get my photos "right" when I'm looking through the camera. I don't want to "fix it in Photoshop" at some later time. Take a class or workshop with me and you'll hear me repeat often "get it right in the camera if you want to be a photographer. Say you'll fix it in Photoshop and you become a computer operator." However, having said all that, I will tell you about the three situations when I most often do use Photoshop.

1. Digital SLR cameras get dust on the sensor. No matter how much you clean your sensor or how careful you are when changing lenses, dust will show up. I use Photoshop to take away those dreaded dust spots on my images.

2. I love shooting and displaying panoramic images. One of my PHD cameras has a panorama assist mode that makes taking the sequence of shots a breeze. These images must be "stitched" together with computer software. I use Photoshop for this and it is fun and remarkably easy.

3. By far, my new favorite use of Photoshop is what I call my two-shot exposure technique. I learned this great tip from my friend Rod Barbee (www.barbeephoto.com). Use this technique in situations where the overall contrast of a scene you're shooting is too great for the digital sensor to handle. Many times a graduated neutral density filter can help this problem, but when the filter simply won't do the job, I turn to this technique. The steps are as follows. You're out in the field shooting, and your scene has an overall exposure latitude problem—the sun is hitting the mountain but not your foreground, for example. Figure out your aperture and shutter speed settings for both the bright and dark areas of the scene. Remember those settings. Lock your camera on your tripod so that the shots have the same exact composition. Now shoot twice: one shot should have the foreground exposed correctly; the other, the background. Later, in Photoshop, you merely merge or add the shots together. The result is one photo where both the foreground and background are correctly exposed. (Thanks, Rod.)

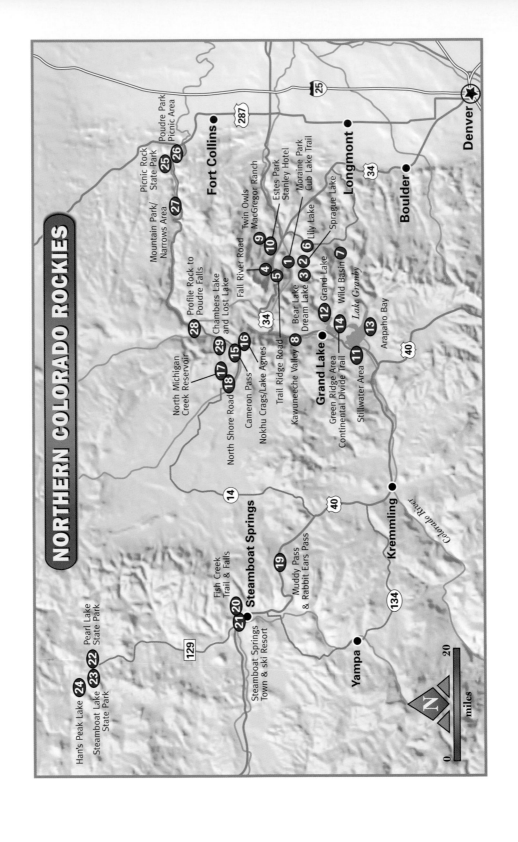

NORTHERN COLORADO ROCKIES

Han's Peak Lake **24**

Pearl Lake
State Park

23 **22**

Steamboat Lake
State Park

129

Fish Creek
Trail & Falls

21 **20**

Steamboat Springs

Steamboat Springs
Town & ski Resort

Muddy Pass
& Rabbit Ears Pass

19

14

40

Yampa ●

134

Kremmling ●

Colorado River

Poudre Park
Picnic Area

25

Picnic Rock
State Park

26

25

Fort Collins ●

287

25

Denver ★

Longmont ●

34

Boulder ●

Mountain Park/
Narrows Area

27

Profile Rock to
Poudre Falls

28

Chambers Lake
and Lost Lake

29

15 **16**

17

18

North Shore Road

North Michigan
Creek Reservoir

Cameron Pass

Nokhu Crags/Lake Agnes

Trail Ridge Road

34

Kawuneeche Valley **8**

Bear Lake
Dream Lake

4
5

Fall River Road

Twin Owls
MacGregor Ranch

Estes Park
Stanley Hotel

9
10

1

2

3

6

Lily Lake

Moraine Park
Cub Lake Trail

Sprague Lake

7

Grand Lake

12

Wild Basin

14

13

Lake Granby

Arapaho Bay

Grand Lake ●

Green Ridge Area

Continental Divide Trail

11

Stillwater Area

40

N

miles

0 20

I. Northern Colorado Rockies

Rocky Mountain National Park Area

General Description: Rocky Mountain National Park became our nation's tenth national park in 1915. Thirty percent of the park is treeless tundra or alpine ecosystem, where winter dominates much of the year and the summer season is spectacular but fleeting. Trail Ridge Road (US 34) is the only through road in the park. Glacier-sculpted peaks, valleys, and lakes are everywhere in Rocky Mountain National Park, as is wildlife—primarily elk, mule deer, and bighorn sheep. Be prepared to pay an entrance fee.

Directions: US 34 and 36 and CO 7 all converge in the town of Estes Park, the major gateway to the national park's east side. US 34 crosses the park and provides access to its western half.

Seasonal Influences: Rocky Mountain National Park becomes a two-section park during the winter. From about mid-October to June, Trail Ridge Road (US 34) is closed from Many Parks Curve on the east side to the Colorado River trailhead on the west side.

Where: North-central Colorado, reached by US 34, US 36, or CO 7

DeLorme Gazetteer: Pages 28–29

Noted For: Accessible alpine habitat, glacially carved peaks and valleys, mountain scenery, and wildlife

Best Times: Late June for flowers, late September for fall colors and bugling elk, mid-February for lack of crowds and acres of snowy trees

Accommodations and Services: Town of Estes Park on east side, town of Grand Lake on west side, and camping throughout the park

Diversions: Festivals in Estes Park, hiking, and mountain climbing

Moraine Park Area/Cub Lake Trail (1)

Moraine Park is a wide valley with a gently flowing stream curving its way through. Some of the best views of Longs Peak are from Moraine Park. The morning sun lights up the peak brilliantly. Look for nice sections of the stream that S-curve toward Longs Peak or use the stand of aspen trees at the Moraine Park Road/Bear Creek Road junction as a foreground. The entire valley is usually open to off-trail hiking and exploring (closed during elk rut season).

The Moraine Park area is one of my favorite places to watch and photograph elk. Do your elk photography from the safety of your car or from designated pull-offs—please don't give photographers a bad name by chasing elk around in closed areas. Bring a long lens of 400–500mm if you want portrait shots.

The Cub Lake Trail is a nice easy hike. The path is mostly flat and passes through gorgeous

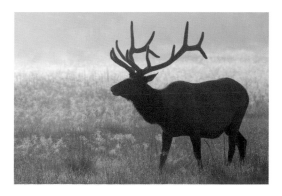

Male elk in velvet, Cub Lake Trail

Sprague Lake

meadows for the first half, then heads up into mixed aspen forests that become brilliant with color in the fall. This trail is a great place to watch and photograph the rising sun. I usually end up shooting sunrise, then spending all my time working meadow flowers in the summer, elk and frosty meadow grasses in the fall, and snow patterns in the winter. Because of all the diversions, I rarely make it to Cub Lake. The lake has lily pads and aquatic plants to photograph if you do get all the way there.

Arrive early during the busy summer season if you want a parking space at the trailhead. The 10 or 12 spots fill quickly.

Directions: From Estes Park go in the Beaver Meadows entrance station, turn south off US 36, onto the Bear Lake Road, then west onto the Moraine Park Road. The Cub Lake trailhead is on the Moraine Park Road, south of the Moraine Park campground and well marked.

Sprague Lake (2)

Sprague Lake is a perfect little mountain lake, with easy access, a nice trail, and outstanding mountain reflection shots. The lake's flat 0.5-mile trail around its circumference provides easy opportunities to set up for shots. Best time of day is the morning. After a calm night the surface of the lake becomes glass-flat; from its northeast shore, the reflections of Hallett Peak and Flat Top Mountain are primo. Morning mist can add even more magic to the place. Use the large rocks that stick above the water at the extreme southeast end of the lake as a foreground element.

Sprague Lake is best during June, when the lake becomes ice-free and the background peaks still have lots of snow. Late September and early October can also be especially scenic if the peaks get an autumn dusting of snow, with misty mornings a good possibility at this time of year.

Directions: From US 36, go south on Bear Lake Road about 6 miles to the well-signed Sprague Lake trailhead and picnic area. Turn south onto this road and park at the road's end.

Bear Lake and Dream Lake Trails (3)

These two lakes are wildly popular and may be the most frequently visited spots in Rocky Mountain National Park. Get an early start or go during the off-season to avoid crowds. Places like Bear and Dream Lakes are popular for a reason—because they are spectacular!

Bear Lake has an easy 0.6-mile loop trail around its circumference. My favorite shots from Bear Lake are from the northern shore, using the huge boulders at lakeside as foregrounds, and also from the hillside just behind this area. This hillside is covered in aspen trees, which turn a brilliant yellow in September and make a great foreground.

Dream Lake is reached from this same trailhead after a moderately strenuous hike of 1.1 miles. Except during the dead of winter (an excellent time to do this hike) there will be throngs of people on this trail. The reason will be apparent upon reaching the lake, which certainly lives up to its name. Hallett Peak rises dramatically from behind the lake in a scene out of, well, a Rocky Mountain dream, perhaps. If the waters are calm, the reflections of Hallett Peak in Dream Lake will make your shutter finger atwitter with excitement. Great shots can be found all along the north shore of Dream Lake. Look for interesting fir and spruce trees reflected in the water, or photograph the fly-fishermen who are after native cutthroat trout. Mornings are best.

Directions: Take Bear Lake Road south off CO 36 till it ends. This road is so popular in midsummer that parking spaces become extinct past about 9 AM. There is an excellent seasonal shuttle service with ample parking at Glacier Basin (4 miles from road's end). The buses start running at 5:30 AM during peak times, so photographers can get that early start.

Fall River Road (4)

This is the historic first roadway built across Rocky Mountain National Park. It is a 9-mile, curving dirt road suitable for passenger vehicles. The road follows the path of the Fall River and provides some nice opportunities to photograph falling water. Golden aspen trees are a bonus during the fall season.

The road is one way (up only) to the top. Chasm Falls is the first signed parking area at

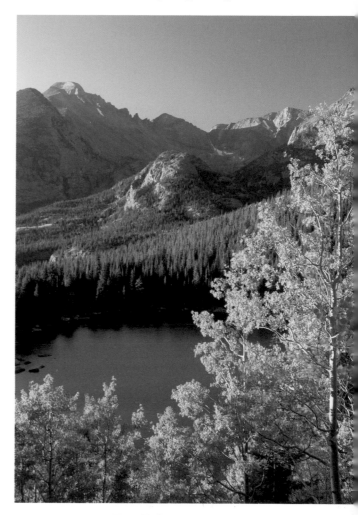

Bear Lake

about the 1.5-mile point. I find this falls only mildly interesting, and at its best during spring runoff. At other times of the year, the series of cascades above the falls make more interesting shots. Remember: a diffused sun (i.e., clouds) plus flowing water equals better water shots.

Continuing upward, you'll pass through some stands of aspen trees, which can always keep a photographer busy during the autumn season. Watch for elk, deer, and other wildlife along this road. A small, unnamed falls at mile marker 5 makes a very pretty intimate scene shot.

After about mile 7.5 you'll be above treeline with expansive views in all directions. Watch for a couple of small ponds, which act like reflecting pools for the surrounding peaks. Dur-ing the summer, grazing elk can almost always be seen in this area. The road terminates at the Alpine Visitor Center.

Directions: Fall River Road starts at the far end of the Endovalley Road. Take US 34 from the Fall River Visitor Center, go 2 miles west on it, and turn west onto the well-signed Endovalley Road.

Trail Ridge Road, Hidden Valley to Medicine Bow Curve (5)

Trail Ridge Road is North America's highest major through highway (US 34). Great photographs can be found anywhere along the way if your eye is keen and the light is good. I'll cover the top spots traveling east to west.

Hidden Valley offers a wonderfully slow

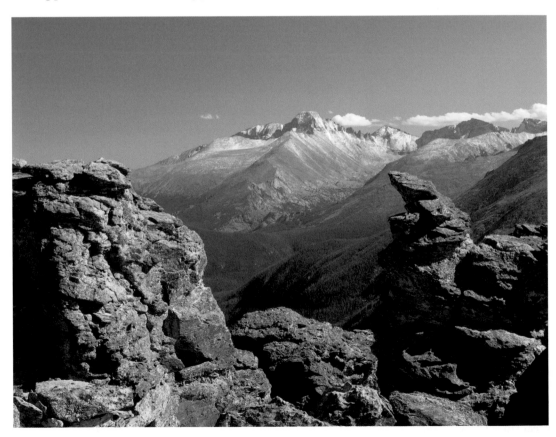

Longs Peak through Rock Cut

meandering stream flowing through a pretty little valley. When the aspen leaves are yellow and falling into the stream, great intimate landscapes result. Wander around here, along the stream and up on the hills, and find a combination of aspens and flowing water for your camera.

Many Parks Curve is the next major stop heading west on Trail Ridge. This spot provides perhaps the best views of Longs Peak in the park. Especially good at sunrise and after a fresh snow, this is a classic Rocky Mountain National Park viewpoint. Use one of the huge pine trees just off the boardwalk as a foreground element. This is as far as you can go west on Trail Ridge during winter. When the road is open, continue west to Rainbow Curve.

Rainbow Curve offers a wide-open expansive view to the east and is a good spot to watch the sunrise. Look for some tall pine trees that you can silhouette against a fiery red sunrise. Rainbow Curve is also a good spot to photograph smaller wildlife such as ground squirrels, chipmunks, songbirds, and pika.

Stop at Forest Canyon overlook for alpine flowers that peak sometime in June, then be sure to spend some time at Rock Cut, my favorite spot along Trail Ridge Road.

Rock Cut has stunning 360-degree mountain views, sunsets, wildlife, carpets of summer flowers, a classic Longs Peak shot, and more. From the parking area, one of the best Longs Peak shots is 100 yards east. Climb the small rock hill where the road cuts through the granite and, looking southeast, you'll see Longs Peak. Summer afternoon sunshine bathes the park's highest peak in beautiful light. Use the rocks in front of you to give lots of depth to the shot.

The short 0.5-mile Tundra Communities Trail provides access to tundra flowers and great sunset views. Watch for elk and bighorn sheep here. Back on Trail Ridge Road, a stop at Gore Range pull-off makes a nice sunset spot as the summer sun dips below the Never Summer Range. There are no trees here for foregrounds, so use a longer lens and silhouette the mountains, emphasizing any color in the Colorado sky.

Continuing west, you'll find the Alpine Visitor Center, with a small café and provisions for sale. This is a good spot to inquire about any interesting wildlife sightings.

Medicine Bow Curve is the last stop on my Trail Ridge photo tour. Named because you can see all the way into Wyoming's Medicine Bow Mountains, this pull-off offers great wide-open views of the Never Summer Range and untouched pine forest expanses. I've photographed both sunrise and sunsets here with good results.

Directions: Trail Ridge Road is US 34 and runs east/west through Rocky Mountain National Park. Trail Ridge Road is closed from Many Parks Curve westward to the Colorado River trailhead from about mid-October to June depending on snowpack.

Lily Lake Area (6)

The Lily Lake Area of Rocky Mountain National Park was slated to become condominiums, but was bought and preserved as part of the park by the Rocky Mountain Nature Association (RMNA). This area offers some nice photography so I, for one, am grateful to the association. I am also an instructor in their excellent seminar program. To show your appreciation and support of RMNA, take one of their seminars in Rocky Mountain National Park (www.RMNA.org).

A short, easy trail follows the Lily Lake shoreline and offers clear views of Longs Peak. On calm mornings, the park's highest mountain will be reflected in Lily Lake. Remember to find an interesting foreground.

Head south on CO 7, past Lily Lake about

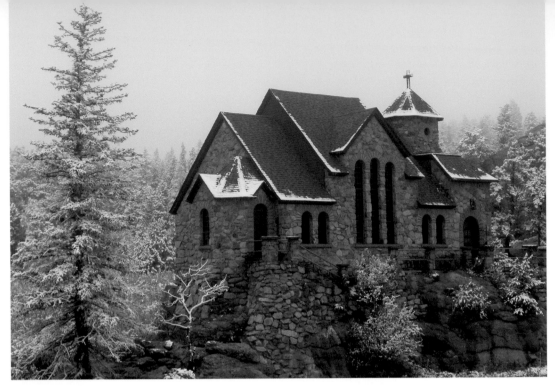

The "chapel on the rock" at Camp St. Malo

4 miles, to photograph a great piece of architecture—the "chapel on the rock" at Camp St. Malo. Built in 1935, the church is set below 13,911-foot Mount Meeker, and is stunning. Get out of your car and explore around for the right angle. Use the small beaver pond just below the chapel for reflection shots.

Directions: Lily Lake is about 6 miles south of Estes Park on CO 7. From US 36, the Lily Lake Road (CO 7) heads south just before Lake Estes. To reach St. Malo's, continue south past Lily Lake for about 4 miles until you see the church on the west side of CO 7.

Wild Basin Area (7)

The Wild Basin Area provides a good escape from summer crowds. In most national parks, crowds can be avoided merely by taking a hike. This is especially true for the Wild Basin Area of Rocky Mountain National Park. My favorite hike is the 2.7-mile hike along St. Vrain Creek that passes petite Copeland Falls, gorgeous Calypso Cascades, and then Ouzel Falls. This is the type of hike that could keep a photographer busy all day. As you walk along the creek, look for and shoot any of the little cascades and rock formations that catch your eye. Experiment with slow shutter speeds—even up to a couple seconds long—and use your tripod and a polarizer for best results. The best light for this hike is on a cloudy day.

The Wild Basin Area is also very good for roadside flowers in the summer; again, a cloudy day keeps the light even. Wild Basin is open year-round and deep winter snows provide the perfect backdrop to cross-country skiing photos or shots of snow-flecked pines.

Directions: Take CO 7 south from Estes Park for about 13 miles. The Wild Basin entrance is on the west side of the road and well signed.

The Wild Basin Road then goes west for 2 miles to the Wild Basin trailhead.

Kawuneeche Valley (8)

This area is known as the "western part" of Rocky Mountain National Park. The Kawuneeche Valley is good any time of the year but I especially like it during autumn. Bugling elk are a favorite photo subject and, during the fall rut, the Kawuneeche Valley has plenty. Just get up early and drive to any of the valley's meadows and the elk will be there—sometimes by the hundreds. Testosterone-filled male elk can be dangerous, so it's always best to shoot from the roadside or use your car as a moving blind.

Moose are also here in good numbers (they are not on the eastern side of the park). The valley is full of the willow plants that moose relish and these traffic-stopping mammals can be seen all throughout the valley.

For scenic shots, the Kawuneeche Valley has lots to offer too. Drive the Kawuneeche Valley Road early in the morning when fog or mist is a good possibility over the meandering Colorado River.

Walk along the Colorado River starting at the Coyote Valley trailhead or the Holzwarth Historic Site (a 1920s guest ranch) and find compositions that include the curving river and those high peaks of the Never Summer Range. If a moose or bugling elk gets into your scenic shot, that's OK too.

Returning to the moose hunt for you wildlife photographers, check the willow flats at the Timber Creek campground and also the Beaver Ponds and Beaver Creek picnic areas about 8 miles north of the entrance station.

The last stop on my Kawuneechee Valley tour is the Colorado River trailhead—an easy hike with moose potential, a meandering stream, a couple of beaver ponds, and abundant summer flowers, all good subjects for the nature photographer.

Directions: The Kawuneechee Valley starts at the Grand Lake entrance station, which is just north of the town of Grand Lake on US 34.

Twin Owls/MacGregor Ranch (9)

This out-of-the-way area is great for crowd escaping, old ranch scenes, and shots of Longs Peak. Just north of a conservation easement area, the Twin Owls are a couple of rounded

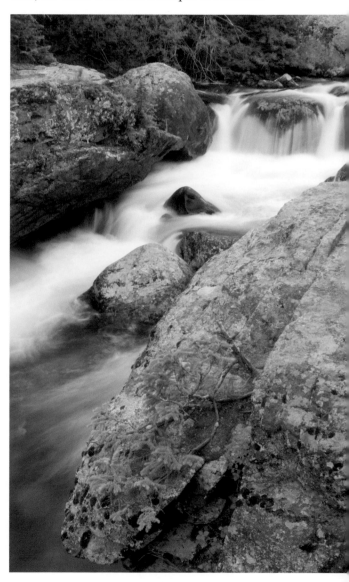

Copeland Falls

rock formations that form part of Lumpy Ridge.

This is a morning location. Arrive at the Twin Owls/Black Canyon trailhead early in the morning and walk the Black Canyon Trail to the northwest. Look for sweeping views down the valley that lead the eye to dominant Longs Peak. Summer is colorful here as lots of flowers fill the meadows. August brings a golden color to all the now-dry meadow plants. There are some aspens in the area, which can add brilliant yellow color to your Longs Peak shots during late September.

You crossed private property to get to this trailhead, now go back and stop at the Mac-Gregor Ranch information building. Pay a small fee for access to this historic ranch's photo opportunities. Wander around looking for and shooting old barn scenes, close-ups of rusted ranch tools, and the occasional horse or cowboy.

Directions: From Estes Park take the US 34 business bypass road to the west, then turn north on MacGregor Avenue and follow the signs to the Twin Owls trailhead.

Estes Park/Stanley Hotel Area (10)

The town of Estes Park has an easily walkable downtown area with lots of shops and plenty of tourists to fill them. My favorite shooting area in town is the Stanley Hotel. This historic place was built in 1909 and has been featured in several movies, the most famous of them Stephen King's *The Shining*. The gleaming white building commands a spectacular view of the peaks of Rocky Mountain National Park from its ridge over the town. Photographers are certainly welcome to visit and shoot the hotel, which is especially appealing in late evening light. Details of the town's architecture, the area's gorgeous flowers, and the herds of friendly elk that sometimes outnumber the guests are also potential subjects.

Directions: From US 36 in Estes Park go west onto the US 34 business bypass road, then take second right into the Stanley Hotel.

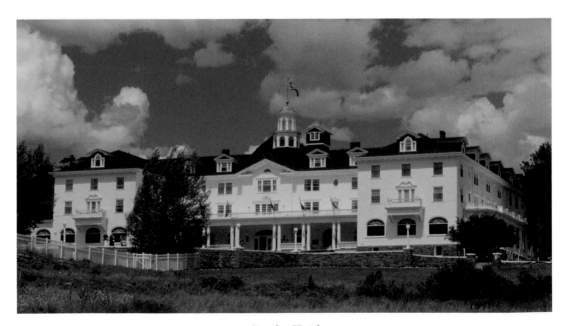

Stanley Hotel

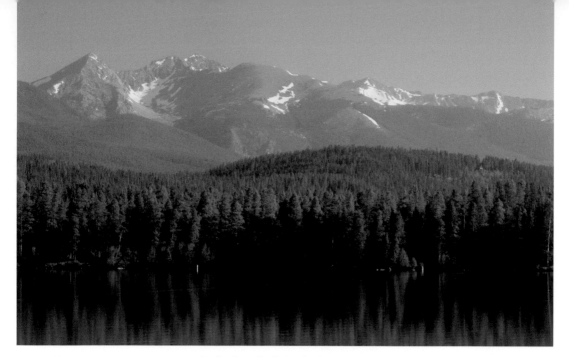

Lake Granby & Rocky Mountains

Lake Granby Area

General Description: Lake Granby is the second of many lakes and reservoirs created by damming the Colorado River. (Shadow Mountain Lake just north of Lake Granby is the first.) This large lake is part of the Arapaho National Recreation Area, just southwest of Rocky Mountain National Park. The level of Lake Granby fluctuates with the amount of snow runoff, but even during dry years the water is abundant, since the lake is huge. All of this water provides infinite outdoor recreation opportunities and places for photographers to shoot. Be prepared to pay an entrance fee.

Directions: From the town of Granby and US 40, turn north onto US 34. Travel about 4.5 miles on US 34 to the Arapaho National Recreation Area. US 34 skirts the entire western edge of Lake Granby.

Where: North-central Colorado, reached by US 34, north of US 40

DeLorme Gazetteer: Page 28

Noted For: Large lakes, boating and water recreation, mountain scenery, and wildlife

Best Times: June for flowers and ospreys, midsummer for boating/sailing shots

Accommodations and Services: Towns of Granby and Grand Lake, camping throughout the area

Diversions: fishing, boating, and snowmobiling

Seasonal Influences: This area and most of its facilities are open year-round. US 34 is open all year (closed in winter at the Colorado River trailhead in RMNP), providing photographers with winter access to this area, as well as the western half of Rocky Mountain National Park.

Adams Falls

The Arapaho Bay Road is maintained only during the spring and summer, so winter access is on foot or by snowmobile.

Stillwater Area (11)

Lake scenes with snowcapped mountains as a backdrop and water recreation shots are what I look for when I visit here. Park in one of the Stillwater picnic spots and walk the easily accessible shoreline looking for shots. Calm spring nights are prime time to wait here and watch the peaks as they become bathed in the last glow of evening light. If you are lucky, the peaks will be reflected in Lake Granby. Use the shoreline itself or colorful water plants as foreground material for your shots of the craggy peaks looking northeast across the lake and into Rocky Mountain National Park. If a sailboat presents itself, use that as a scale element.

More watercraft shots can be found at the Lake Granby marina, 1.5 miles south of the Stillwater area on US 34. Park at the marina and walk the sailboat docks. Use a wide-angle lens pointed at the brightly colored boats—they make a great foreground for your lake and mountain shots.

Directions: The Stillwater area is a well-signed camping/picnicking/boat ramp right off US 34. The turnoff for Stillwater is on the east side of the highway south of Grand Lake.

Grand Lake (12)

Grand Lake is the largest natural body of water in Colorado. The town of Grand Lake is the quintessential Colorado mountain town, and one of my favorite Grand Lake shooting spots is the downtown area itself. Put on a long lens (image stabilized is best) and pick out distant landscapes or street shots of people enjoying the Colorado summer. Wander down to the marina for water views and boating shots.

The best views of Grand Lake itself appear during the late afternoon and evening at Point Park. This park is a refreshing natural area amid the developed shoreline of Grand Lake. Find this small park by following Marina Drive to Lakeshore Drive. On a calm evening, as the sun is setting behind you, the peaks of Rocky Mountain National Park will light up and be reflected in the still waters of Grand Lake. A sailboat or red canoe just offshore would be a wonderful scale element for your lake shots.

There are some completely natural areas to shoot near Grand Lake. The East Inlet trailhead and entrance into Rocky Mountain National Park is on the east side of Grand Lake. A

fine place to day-hike, the East Inlet Trail also offers us equipment-laden photographers a short destination hike to Adams Falls, an easy 0.3-mile walk. This falls drops 55 feet in two separate cascades. Photographically, I like the lower falls better than the upper, but it is a challenging rock scramble to get down to; go carefully. Adams Falls is best in late summer.

Directions: Get to the town of Grand Lake and the East Inlet trailhead by following the West Portal Road, east off US 34, north of Granby.

Arapaho Bay (13)

Arapaho Bay is the long southeastern arm of Lake Granby. County Road 6 (CR 6) follows this shoreline for 10 miles and provides photographers with a host of opportunities. Mornings will provide a front-lit lakeshore and distant mountains. Evenings will give you a chance to shoot the sunset over the lake.

Bird photographers should watch closely in the trees between the road and the lake for osprey nests. Once you locate a nest you'll be able to photograph the parents right from the road as they bring fish back to the young. As with all bird photography, bring lots of lens power (600mm is about the minimum). Chick-rearing season is June and July. The end of the road is Arapaho Bay itself, a fine place to shoot sunset.

Directions: Access Arapaho Bay from CR 6, which intersects with US 34 at Rainbow Bay, about 5 miles north of the town of Granby. Turn east and follow this paved, then dirt, road 10 miles until it ends.

Green Ridge Area/Continental Divide Trail (14)

This site is part of the Arapaho National Recreation Area, and also Rocky Mountain National Park. Park your vehicle at the Shadow Mountain Dam and start photographing right here. Early morning light will bathe Shadow Mountain Lake and its numerous islets in a lustrous radiance. Pull out a longer lens and concentrate on the distant peaks or sailboats cruising the lake in summer. Also on summer evenings, this is a good spot to watch the sun set behind the lake.

The other photo spot here is the East Shore Trail. Walk across the dam and veer to the right on the far side of the dam. A sign lets you know that you are now entering Rocky Mountain National Park. Walk as far or as little as you like; this trail goes south all the way to Monarch Lake. I never get very far because of all the photography distractions. The trail follows the meandering and crystal-clear Colorado River, which makes a good subject itself. There are also lots and lots of spring and summer wildflowers along this trail and I've photographed these for hours without ever moving very far. For calypso orchid fans, this trail is not to be missed. Best time on this trail for flowers is mid-June.

Directions: Take County Road 66 east off US 34 and follow the signs to the Green Ridge Complex. The road ends at the Shadow Mountain Dam.

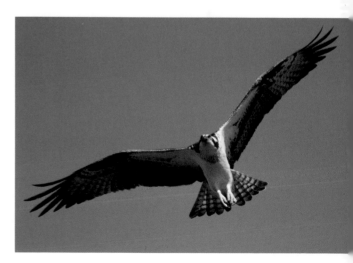

Osprey, Arapaho Bay

State Forest State Park Area

General Description: This is the crossroads of three wilderness areas, two national forests, and Colorado's largest state park. It is a mountain lover's heaven with the peaks of the Medicine Bow and Never Summer Mountains rising to dizzying heights in every direction. There are no big towns nearby, which gives visitors a real feeling of being in a wild place—which you are. Just be sure to get full provisions before you travel here, as gas, food, and supplies will be quite some distance away.

Directions: CO 14 is the only main road going through this area. It runs east/west. You can get on CO 14 either from US 287 north of Fort Collins or from US 40 southeast of Steamboat Springs.

Seasonal Influences: CO 14 is open and maintained all year long. However, access to the photo sites differs drastically from summer

Where: Extreme north-central Colorado, reached by CO 14

DeLorme Gazetteer: Page 18

Noted For: True wilderness, remoteness, mountain scenery, and wildlife

Best Times: June for flowers, midwinter for snowy peaks

Accommodations and Services: Few and far between, town of Walden, camping throughout the area

Diversions: Fishing, hiking, and cross-country skiing

to winter. Once the areas are clear of snow, usually late May, access is easy, but during the winter the road to Lake Agnes and the North Shore Road is closed. Access to the other areas of Colorado State Forest State Park is limited during winter and may require chains for your tires and/or snowshoes for your feet.

Medicine Bow Range

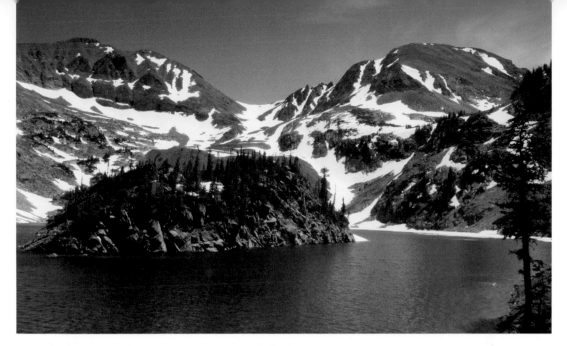

Lake Agnes

Cameron Pass (15)

Cameron Pass is at an elevation of 10,276 feet. Photo opportunities here are of intimate scenes rather than the endless mountain views offered by some passes. The two best times to be here are just after a fresh snowfall decks the conifers in powder, and when winter snows melt and fields of flowers emerge. In early June you'll be treated to a mixed yellow and green palette of color as dandelions and avalanche lilies fill every open space on either side of the pass. Besides spending lots of time shooting the flowers, I like to explore north (east on CO 14) of the pass along the stream that eventually becomes the Poudre River. Wander along the stream looking for small cascades and interesting rock patterns. Use your tripod, vary your shutter speed, and experiment with sharp, then blurry, then really blurry water.

Directions: Cameron Pass is on CO 14, about 9 miles east of the tiny town of Gould (which has no services).

Nokhu Crags/Lake Agnes (16)

The Nokhu Crags are impressive rock formations, which form the northern limit of the Never Summer Mountain Range. There are a couple of signed highway pull-offs where you can view and photograph the crags. I find the crags and surrounding peaks most impressive during the winter when the crags rise up dramatically out of the snow. Late evening light is best.

During the summer you can get off CO 14 and explore this wonderful area. A signed road, 62, off CO 14, leads to the Lake Agnes trailhead. A high-clearance vehicle is required. Park at the Lake Agnes trailhead, and then walk the 0.8 mile to Lake Agnes. I know, you just want to drive right to the photo spots without any walking, but the scenes at the end of this short (but steep) hike are worth your effort getting there.

Lake Agnes is an impressive high mountain lake with a couple of tiny islets and in-your-face views of the Nokhu Crags and surrounding peaks. Wander the 1-mile circumference trail,

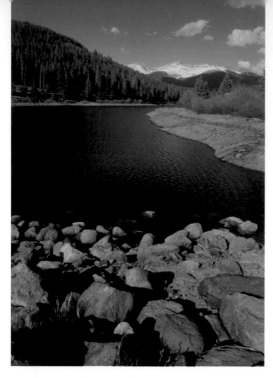

Along North Shore Road

Medicine Bow Mountains nicely. Use the aspen bole fence as a leading line, or get low and emphasize some of the millions of dandelions that bloom here in June.

In winter, Michigan Creek Reservoir freezes and this area gets hundreds of inches of snow, turning everything into a winter wonderland. The rentable yurts of Colorado State Forest State Park provide a unique and comfortable way to stay and photograph during the snow season. Some impressive snow scenics can be made right from the front porch of the Grass Creek yurt—a 1-mile snowshoe or cross-country ski trip in. Visit www.neversummer nordic.com for reservations.

Directions: Take CO 14 until you are 2 miles northwest of the tiny town of Gould (no services) and you will find the well-signed North Michigan Creek Reservoir Road, which heads east.

North Shore Road (18)

The North Shore Road is a continuation of the North Michigan Creek Reservoir Road within Colorado State Forest State Park. Take the north fork along the lake, watch for and shoot the gorgeous mountain reflections if the water is calm, then continue driving east. Boaters, fishermen, and moose are also possible subjects along the lake portion of this road. Past the reservoir the pavement ends but the dirt road is smooth and fine for passenger cars. The Medicine Bow Mountains loom to the east above impossibly lush fields of spring flowers in June and July. These mountains look better when snowcapped in fall, winter, and spring.

Directions: Take CO 14 until you are 2 miles northwest of the tiny town of Gould (no services) and find the well-signed North Michigan Creek Reservoir Road, which heads east. Take the north (left) fork at the road junction before the reservoir.

use the widest lens you own, and frame up the lake and the crags in a quintessential Colorado mountain shot. You can thank me later for sending you up here. Best time is late afternoon/early evening light. Be sure to save enough daylight to walk back to your vehicle.

Directions: The Lake Agnes Road is 62 and is well signed. It heads south off CO 14 about 2.5 miles west of Cameron Pass.

North Michigan Creek Reservoir (17)

This site is within Colorado State Forest State Park, and is the most accessible area of Colorado's largest state park. Snowcapped mountains, aspen bole fences, aspen trees, a pretty lake, and spring wildflowers in profusion make this area a photographer's dream. Visit in early June for flowers. Park at the end of the South Fork Road and wander about with camera and tripod. Shoot to the east during the afternoon and evening when the sun front-lights the

Steamboat Springs Area

General Description: This area of the northern Colorado Rockies is famous for its skiing through the deep snow called "champagne powder" by those in the know. The skiing and ski photography are great here and family friendly too, with special kids-only terrain and kids-ski-free deals throughout the season. The Steamboat area is a true four-season vacation mecca, which offers snowcapped peaks, mountain lakes, several picturesque state parks, and endless outdoor sports subjects for photographers. Add to all the photo subjects a whole bunch of natural hot springs for soaking the day's dust away, and I don't know of a better place to spend a few days exploring and photographing.

Where: North-central Colorado, reached by US 40

DeLorme Gazetteer: Pages 16, 26

Noted For: True western town, ski resort, wildflowers, and mountain scenery

Best Times: June and July for flowers, February for skiing under blue skies

Accommodations and Services: Town of Steamboat Springs, camping throughout the area

Diversions: Festivals in town, fishing, and soaking in hot springs

Directions: The town of Steamboat Springs is some 157 miles northwest of Denver. From Denver take I-70 west to US 40 (exit 233). Follow US 40 all the way to Steamboat Springs.

Seasonal Influences: Steamboat Springs is a major ski resort off a major U.S. highway and thus is maintained all year. Heavy winter snowstorms may close Rabbit Ears Pass temporarily, but lots of effort and resources go into keeping the roads around Steamboat open every day of the year.

Muddy Pass and Rabbit Ears Pass (19)

Neither of these passes is all that high in elevation, and the scenic views from both are somewhat limited due to thick conifer forests. So why, you ask, am I sending you here to photograph? Flowers, flowers, and more flowers. Next to the Crested Butte area, these two passes have more spring and summer wildflowers than any other frontcountry place I've ever seen in Colorado. In early June, avalanche lilies and dandelions start off the colorful procession with a bang. Miles of terrain are covered with displays of yellow. The progression of colorful

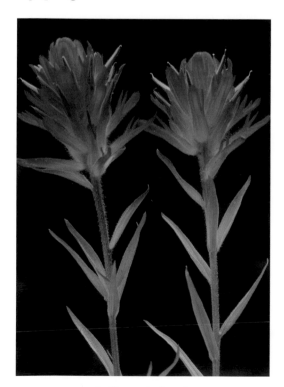

Indian paintbrush

flowers changes as the summer advances, but it is always an amazing show of fecundity.

During the flower season, you could set up your base camp at Dumont Lake, which is along Forest Road 315, and explore this area for several days before you tired of all the wildflowers.

Additional subjects emerge here during other seasons. Check out the reflections of fall aspens in Muddy Pass Lake during late September. In winter, these two passes are popular with snowmobilers and cross-country skiers, so winter sports photographers have lots of potential subjects here.

Directions: Both Muddy and Rabbit Ears Passes are along US 40. Muddy Pass is at the junction of US 40 and CO 14, and Rabbit Ears Pass is 3 miles west.

Fish Creek Trail and Falls (20)

This is one of my favorite Colorado waterfalls. It is a gorgeous, cascading drop of 280 feet. Fish Creek Falls runs year-round (barely during midwinter) but the best time to photograph it is during the late spring. The easy trail to the falls follows an impossibly clear creek with interesting rock patterns and small cascade possibilities. The best photos of the falls are from the footbridge or right in the stream just below the falls. As with most flowing water shots, some cloud cover over the sun will eliminate ugly shadows and contrast on the falls. Use your polarizing filter and remember to try something different, like putting on a long lens and zooming way in on just one small cascading section of flowing water.

Directions: From US 40 in the town of Steamboat Springs, go east on 3rd Street, then veer right onto Fish Creek Falls Road. The trailhead is 4 miles back.

Steamboat Springs Town and Ski Resort (21)

The historic downtown of Steamboat Springs still maintains its western ambiance and small-town hospitality. Photographing the town and its residents is best done in winter, during the Christmas season, when frequent snows put a pretty dusting on everything, and the holiday lights add a cheery glow. This is a downtown area made for walking. Grab a wide-to-medium telephoto zoom and do some street shooting while here. Mountain reflections in windows,

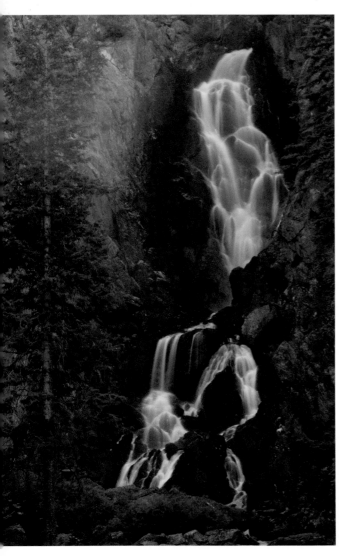

Fish Creek Falls

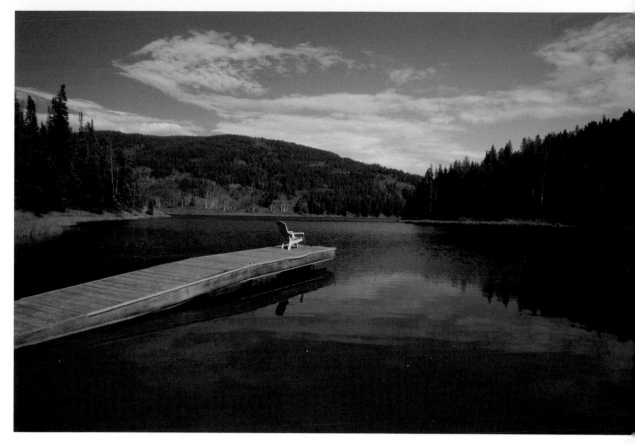

Pearl Lake

real cowboys in ten-gallon hats, families holding hands, famous Olympic medalists, and horse-drawn sleighs are all possible subjects.

The Steamboat Springs ski resort is Colorado's third largest and averages over 300 inches of powder per season. As with all of Colorado's ski resorts, if you are a skier and photographer, stash your compact digital camera in an inside coat pocket, get a lift ticket, catch an early chairlift, and get up high for scenic ski shots with morning light. Non-skiers can take a gondola-only ride to get up high and get great views and scenic mountain photos.

Directions: Steamboat Springs town is right on US 40 157 miles northwest of Denver. The

ski area itself is best reached by free shuttle buses that pick up and drop off all throughout Steamboat.

Pearl Lake State Park (22)

This state park, 25 miles north of Steamboat Springs, is small and quiet with a nice campground and pretty lake to explore. Visit in June and it could take you several hours to travel the 2-mile entrance road to the park itself, because you'll be tempted to stop every 10 feet and photograph the thousands of mule's ears and other spring flowers growing in profusion here.

Once inside the park, head for pristine and peaceful Pearl Lake itself, a lovely place just to walk around with a camera. Take the Pearl

Autumn aspen trees

Lake Trail from the boat dock around the lake for morning reflection shots of nearby peaks and gorgeous pine forest scenes. If there are enough clouds in the sky to hold some color, photograph other morning reflections of simple things such as reeds and cattails.

Directions: North of Steamboat Springs, take County Road 129 (CR 129) north for 23 miles to the well-signed entrance road to Pearl Lake State Park. Park entrance is 2 miles east of CR 129.

Steamboat Lake State Park (23)
This park encompasses the area around Steamboat Lake, a large lake with three full-service campgrounds, good boating, and fishing. Photographers who camp would enjoy the Dutch Hill campground in the sites that overlook the lake. You could roll out of your tent and start shooting right away at the Elk Head Mountains reflected in Steamboat Lake.

My favorite hike at this park is the easy 1.1-mile Tombstone Nature Trail loop for views over the lake and great spring and summer wildflowers.

During the winter, Steamboat Lake State Park is popular with winter sports enthusiasts who take up snowmobiling, cross-country skiing, and ice fishing. Photographers staying down in the town of Steamboat Springs could take a day trip to this state park and would find enough winter scenes to keep them busy.

Directions: North of Steamboat Springs, take CR 129 north for 24 miles to the well-signed entrance road to Steamboat Lake State Park.

Hahn's Peak Lake (24)
This national recreation area is part of the Routt National Forest. In the summer, come here to find wildflowers. The east side day-use area has easy access to the lake and lots of montane flowers. When shooting single flowers, remember that your background is as important as your subject. You want a clean, even-colored background, free of distracting highlights. A cloudy day works wonders for this, or you can diffuse the light with an umbrella or diffusion disc.

Hahn's Peak Lake also makes for a great autumn getaway, especially during late September or early October when the hillsides of aspens turn golden. I especially like the aspen scenes along CR 129 just across from the Hahn's Peak Lake entrance road.

Directions: From the Steamboat Lake State Park visitor center on CR 129, travel 2.2 miles north to Forest Road 486 and go west to the lake.

CO 14 through Poudre Canyon

General Description: This road, which meanders along the Cache la Poudre River, borders four wilderness areas and is surrounded by national forest on all sides. The river is federally designated as wild and scenic, which means that development is limited. This winding, two-lane byway passes through one of the prettiest river canyons in Colorado. The Poudre River itself is one of Colorado's premier summer playgrounds, with rafters, kayakers, campers, hikers, and fishermen enjoying the water and all it offers. Scenic Poudre Canyon offers opportunities for good photos at any of the numerous highway pull-offs, picnic areas, or campgrounds.

Directions: From Fort Collins, travel north on US 287 about 8.5 miles to Ted's Place and the

Where: North-central Colorado, reached by CO 14

DeLorme Gazetteer: Pages 18–20

Noted For: Designated wild and scenic river, river canyon, and watersports

Best Times: Midsummer for rafting and kayaking, late September for fall color

Accommodations and Services: Town of Fort Collins on east end of CO 14, camping throughout the area

Diversions: Whitewater rafting, kayaking, fishing, and summer festivals

junction of 287 and CO 14; head west on 14. Mile markers go down as you travel from Ted's Place west.

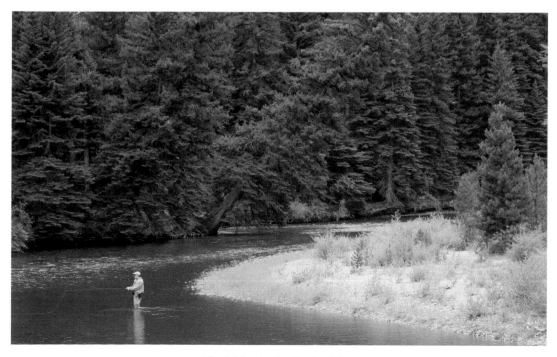

Fly-fishing in the Poudre River

Seasonal Influences: CO 14 is maintained all year, though temporary winter closures from snowstorms are always possible. With springtime comes the big snow melt-off and challenging rapids for rafters and kayakers. Water levels drop during the summer and by autumn the river is more of a meandering stream than a powerful torrent.

Picnic Rock State Park (25)

Here the river is a slow, wide meandering stream even in the springtime. Huge cottonwood trees border the wide-open valley and can be photographed as subjects themselves or as anchors to your river shots. Early spring leaves are an iridescent green and fall cottonwood leaves can range from yellow to copper along this section of river.

Get down to the river and look for early morning reflections of the cottonwoods in still pools or put on a wide-angle lens and photograph the river scene with a fly-fisherman as a scale element.

Directions: This is a small state park located at mile marker 119. Be prepared to pay the entrance fee.

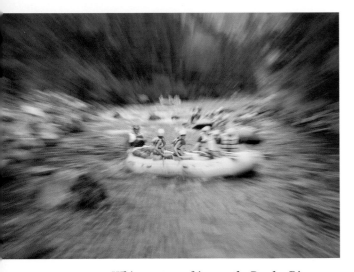

White-water rafting on the Poudre River

Poudre Park Picnic Area (26)

This is where to photograph the action of whitewater rafters. All summer long, groups of rafts put in here and float downstream. Rafting action photography is best from stream level, so walk along the river until you find an outcropping or large river rock that gets you out into the stream a bit and down low.

Vary your shutter speeds when photographing passing rafts. Try a fast shutter speed such as a 500th of a second when the rafters are going over rapids. This will freeze the wild expressions on the rafter's faces and the flying water. When the boats hit a slower section of water change up to get a longer shutter speed like a 15th of a second to add a sense of motion to your shots.

Directions: Poudre Park is at mile marker 111 of CO 14.

Mountain Park/Narrows Area (27)

The Mountain Park area has my favorite Poudre River campground, and some good river scenes to shoot. But before you get here, be sure to stop around mile marker 108 and photograph the impressive rock formations there. Since the Poudre River Canyon runs east and west, you'll get the magic light of morning and evening bouncing off the walls of the steep canyon. Use a longer zoom lens and pick out interesting pieces of the sunlit rocks.

The narrows is west of the Mountain Park area. This section of the Poudre Canyon is very steep and the water roars through here during the spring melt-off. Photographers wishing to shoot rushing water will be happy along this section of the river. Fly-fishermen love this section of the river too, and they can make for good scale elements to your river canyon shots.

Directions: The Mountain Park area is at mile marker 99 of CO 14 and the narrows is the section of river just west of there.

Profile Rock to Poudre Falls (28)

You'll miss Profile Rock if you are driving west, unless you stop at the sign for it, get out, and look back to the east. The rock formation on the south side of the canyon here looks like a man's profile (if you use your imagination). For the best photograph of this wide-nosed phenomenon, shoot in summer with evening light and a clear blue sky, and use a long zoom to get a close-up.

As you continue driving west on this section of CO 14, watch for bighorn sheep, which often come down to the river for a drink, especially during the autumn season. Once you near Sleeping Elephant Mountain there are large stands of aspen trees and wide-open fields that make excellent photo subjects. Find a section of golden aspens that are backlit and position yourself so that the trees are against a shadowed canyon wall. The resulting contrast makes great shots.

Poudre Falls is a narrow canyon falls where the water drops quickly but not all at once. Try zeroing in on a small section or on just a simple cascade for better shots. Use your tripod and a long shutter speed such as a 4th of a second for that silky water effect.

Directions: Follow CO 14 west from well-signed Profile Rock to well-signed Poudre Falls.

Chambers Lake and Lost Lake (29)

These two lakes are easily accessible and are a good escape from summer crowds and for camping out and photographing mountains. The Rawah Wilderness borders Chambers Lake to the west. On calm mornings from the east side of Chambers Lake, you'll see a reflection of 12,000-foot Cameron Peak to photograph. County Road 103 skirts the east side of the lake, so photographers can drive along the water and jump out and shoot when opportunities present themselves. Watch for plentiful

Sunrise at Chambers Lake

mule deer and occasional bighorn sheep along both lakes.

Lost Lake is densely forested but if you can find an opening on the east side, the Medicine Bow Mountains look especially picturesque from here. Midsummer is best.

Directions: Take County Road 103 (CR 103) north off CO 14 at the well-signed Chambers Lake exit, about 6.5 miles north of Cameron Pass.

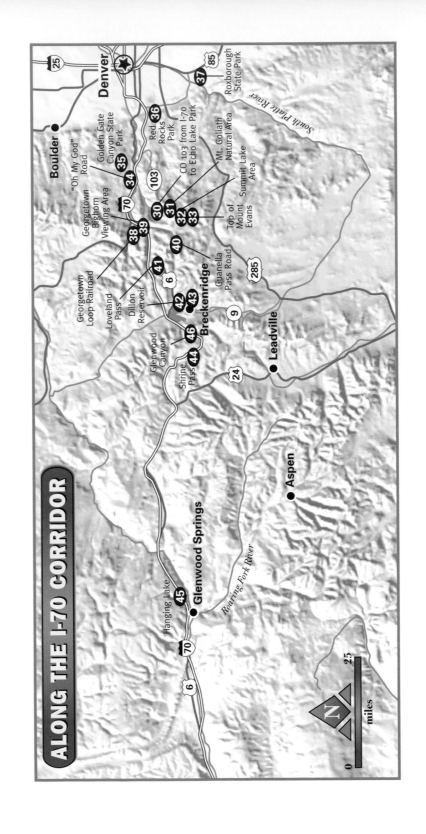

ALONG THE I-70 CORRIDOR

II. Along the I-70 Corridor

Mount Evans Area

General Description: Mount Evans is one of three Colorado fourteeners that can be seen from Denver and all along the Front Range (the mountain range on the eastern edge of the Rockies). It is the mountain most often associated with Denver and is the background for many skyline shots of the city. At 14,264 feet and with a paved road all the way (except for the last 130 feet) to the summit, the Mount Evans road is the highest paved road in North America. Named for John Evans, the 1862–65 governor of Colorado, the mountain is rightly famous for accessible alpine habitat, easily reached fall color, wildlife galore, and endless views.

Directions: Take I-70 west from Denver to the town of Idaho Springs at exit 240. This is CO 103 (also known as the Mount Evans Highway). Alternatively you can get on 103 in Bergen Park, just north of the town of Evergreen, off CO 74.

At Echo Lake Park, the summit road (CO 5) heads south and winds its way for 14 miles to where it dead-ends within 130 feet of the Mount Evans summit. Individual site directions are not included in this section; all sites are either on CO 103 or CO 5.

Seasonal Influences: CO 103 is open and maintained all year long, providing all-season views of Mount Evans. Seasonal closures from large winter storms are always possible. CO 5, which runs from Echo Lake Park to the summit of Mount Evans, is open seasonally, usually from about Memorial Day until mid-September, depending on that first snowfall.

Where: Central Colorado, just west of Denver, reached by I-70

DeLorme Gazetteer: Page 39

Noted For: Colorado fourteener with paved road to top, mountain scenery, wildlife, and wildflowers

Best Times: Midsummer for flowers and wildlife, late September for fall color

Accommodations and Services: Town of Idaho Springs, camping throughout the area

Diversions: Gold mine tours and hiking

Alpine sunflowers

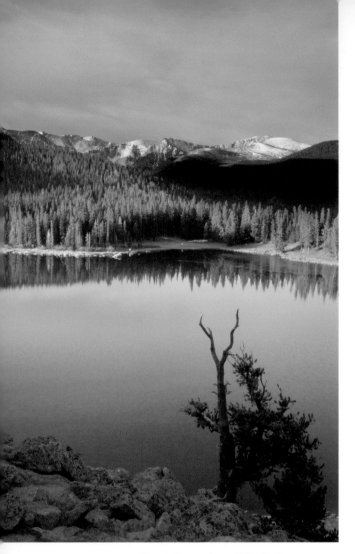

Mount Evans from Echo Lake

Watch for and explore the small stream at around mile 8. The small stream here cascades over rounded boulders and could divert your attention for a while as you search for interesting water and rock compositions. This stream is best when some clouds diffuse the sun.

The Echo Lake Park area has a campground, a lodge with a restaurant, and a lake, which offers a perspective for my favorite photos of Mount Evans. From the lake parking area climb the small hill on the north side of CO 103. Find an opening in the trees here and frame the lake and the mountain in a classic Colorado shot. Add in a bit of fresh snow or some early morning fog and the results are magic.

Mount Goliath Natural Area (31)

On the steep summit road (CO 5) the first decent-sized parking area you'll come to is the Mount Goliath Natural Area. This is a perfect photographer's diversion on the way to the summit of Mount Evans. During the month of June (which week depends on when the snow melted) this area will be jam-packed with alpine wildflowers. Two short loop trails protect the fragile tundra and provide access to the flowers. At prime time, dozens of species should keep your macro lens busy. Get down to flower level, use a diffuser if the sun is out or a reflector for backlit shots, and shoot away. Stay on the trails here—alpine tundra is very fragile.

The other photo subjects here are the bristlecone pine trees. Some of these trees are 1,700 years old. Their twisted, wind-shaped forms give a clue to their age. Get low, use a wide-angle lens, and shoot up into the branches and blue sky to show these great trees at their best. Get in close and photograph the twisted bark patterns if the sky is cloudy.

Summit Lake Area (32)

This is my favorite area of Mount Evans. It is seasonally open after winter snows have been

CO 103 from I-70 to Echo Lake Park (30)

The photography begins at CO 103's junction with the Chicago Lakes area. The conifer forest spreads thickly in all directions from here, and a bit of fresh snow or some sort of atmospheric disturbance makes for dramatic forest images. Good stands of aspen trees all along the first 11 miles of CO 103 provide plenty of diversions in early spring when the aspen leaves are freshly green or in the fall when a golden hue begs you to get the camera out at every turn.

cleared. Visit midweek and you may have the place to yourself—or I should say, yourself and lots of wildlife. Mountain goats eat the lush grasses and wildflowers here. I've photographed herds of goats here that numbered 50 or more. Bighorn sheep are commonly seen here as well. Marmots, pika, ground squirrels, tundra birds, and the occasional weasel all add to the wildlife photographer's delight.

Scenic photos abound here too. Tundra wildflowers or Summit Lake itself both make a good foreground for towering Mount Evans shots. Emphasize the rocks and wide-open expanses of this treeless tundra. Early morning light on the peak and the lake is best.

Top of Mount Evans (33)

After numerous switchbacks and endless steering-wheel turning, the road dead-ends just 130 feet short of the actual Mount Evans summit. Climb the last 130 feet (slowly) for 360-degree views. From here, long-range scenic shots are in order. (That's if the numerous mountain goats don't tempt you to chase them with your camera.) To the north you can see into Rocky Mountain National Park. To the east are Denver and the plains of eastern Colorado. Use a goat or some interesting rocks for foreground, and frame up a classic wide-view mountain shot. Mornings are best for strong directional light and early summer is best for snow on those peaks.

This is high-altitude country and a few precautions are prudent. Watch yourself for dizziness and shortness of breath, and get to lower ground if you feel nauseated. Go slowly and drink lots of water. Storms approach quickly and it can snow any day of the year here so dress in layers and get to your vehicle if lightning is sighted.

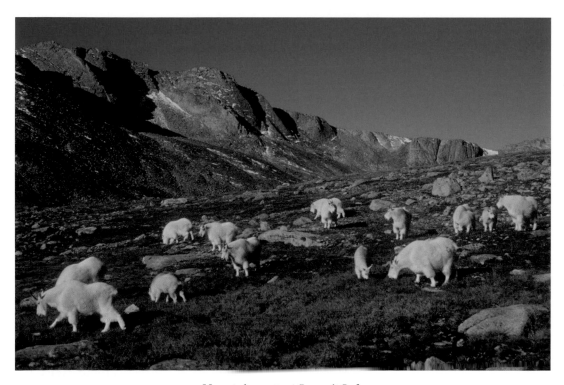

Mountain goats at Summit Lake

CO 119, Nederland to US 6

General Description: If you want to show off some Colorado scenery to your out-of-state visitors, this route never lets you down. CO 119 from Central City to Estes Park is a designated scenic and historic byway. Photographers can drive this route, also known as the Peak to Peak Highway, during any season and get classic Colorado Rockies shots. The road passes by former-mining-towns-turned-gambling-resorts Black Hawk and Central City, takes you near my favorite state park, goes through some classic mountain towns, and provides views, views, and more views.

> **Where:** Central Colorado, just west of Boulder and Denver, reached by I-70
> **DeLorme Gazetteer:** Page 39
> **Noted For:** Fall color, mountain scenery, and wildflowers
> **Best Times:** July and August for flowers, late September for fall color
> **Accommodations and Services:** Towns of Idaho Springs and Nederland, camping throughout the area
> **Diversions:** Gambling at casino towns of Black Hawk and Central City, skiing at Eldora

Directions: From Denver or the town of Golden, take US 6 west into Clear Creek Canyon to the junction with CO 119 and head north. Alternatively you can take I-70 to exit 244 (US 6) and drive east to the junction with 119.

Along "Oh My God" Road

Seasonal Influences: The Peak to Peak Highway is maintained all year long and is paved the entire way. Heavy winter snows may close the road temporarily. Late September is the best time to drive this route and see lots of aspen stands, which will be golden yellow at that time.

"Oh My God" Road (34)

Photographers will enjoy this uncrowded road and its opportunities to shoot classic Rockies scenes with nobody else around. This winding mountain road starts in Idaho Springs and takes you up to the Peak to Peak Highway at Black Hawk. Some of the "Oh My God" Road is unpaved but still OK for passenger cars.

Start photographing at about 4.5 miles up from Idaho Springs where aspen trees make good subjects by themselves and good foregrounds for wider scenes, especially in spring and fall. During the summer, roadside flowers grow in profusion all along the route. On a clear day you can see all the way south to snow-capped Mount Evans. The mountain looks small from here so it is especially important to find a good foreground that will hold the viewer's attention and lead the eye up to the mountain peak.

Directions: From Idaho Springs take Canyon Street off Colorado Boulevard and follow the signs that say "Virginia Canyon" (which is Forest Road 279). Keep following the signs toward Central City.

Golden Gate Canyon State Park (35)

This is my favorite Colorado state park for a number of reasons. It's a short, easy drive to get here from the Denver area, and it has gorgeous scenery, great hiking, good camping, and lots of photography potential. The best time to photograph this park is the first week of October, when the aspen trees will be in prime fall color. Golden Gate Canyon is a large state park. The

Along Mountain Base Road

northern road (CO 72) provides access to three campgrounds and the impressive views of Panorama Point. Photograph from this lookout in morning light. The views here stretch all the way into Rocky Mountain National Park and for a hundred miles of the Front Range.

By far my favorite drive in the park is the Mountain Base Road. This is a slow, winding road with lots and lots of aspens. In early October the golden aspens against a bright blue Colorado sky will tempt you to stop every hundred yards. The road has no shoulder, so for safety's sake you'll need to park in one of the numerous picnic areas or trailheads and walk to photo spots.

Directions: From Golden take CO 93 to the Golden Gate Canyon Road junction and go west to the park entrance. Alternatively you can drive north on CO 93 to the junction with CO 72, go west on 72 to the Gap Road, and go south to the park's northeast entrance.

Denver Foothills

General Description: While not technically part of the current Colorado Rockies, the foothills west of Denver certainly have remnants of the first mountain range that existed here billions of years ago. Some 1.2 billion years of geologic history are contained in the rocks at both Red Rocks Park and Roxborough State Park. I'm including these two scenic locations because they offer lots of photographic potential just a short drive from the metropolitan area of Denver.

Directions: The foothills of Denver are to the west of the metro area. See specific park directions under each individual site listed for this section.

Seasonal Influences: Both Red Rocks and Roxborough Parks are open and photogenic all year. A fresh dusting of snow combined with the red-colored rocks at both places is primo.

Roxborough after a winter storm

Where: Just west of Denver, reached by CO 470 ("the C-470")
DeLorme Gazetteer: Page 40
Noted For: Red rock formations, wildflowers, and wildlife
Best Times: Midwinter for snow scenes, September for wildlife
Accommodations and Services: Denver and metro area
Diversions: Denver attractions: sporting venues, zoo, museums, and downtown area

Red Rocks Park (36)

This park is rightly famous for its outdoor amphitheater, where concertgoers of all types are wowed by the natural acoustics of the place. Photographers will enjoy this 868-acre park for more than just concerts.

The Red Rocks amphitheater itself can make a good subject. It is best at twilight when a concert is scheduled and the place is full of people and lit up by production lights.

Those of you looking for more natural subjects can find those here too. Because there is nothing to the east to block the rising sun, its early morning light strikes the rocks here with an unbelievable warmth. The rocks literally glow red. Balanced Rock, on the western entrance road, makes for an interesting subject. Get low and place the rock against a blue sky. Some puffy white clouds always make scenic shots more interesting. The red rock fins rising towards the sky along the trading post loop trail are also a good bet. Spring flowers bloom in profusion at Red Rocks. Find a thick patch of golden pea or orange paintbrush flowers to use as an interesting foreground for your red rock photos.

My favorite season here is winter. After a fresh snowfall the red rocks will have every edge fringed with white powder. If the sky clears, you'll have a red, white, and blue medley of endless photo opportunities.

Directions: From I-70, take exit 259 and go south to the park entrance. From CO 470, take the Morrison exit onto CO 8, and go west through the town of Morrison to the well-signed park entrance on the right.

Roxborough State Park (37)

The scenic potential of Roxborough, the friendly wildlife, and the short drive from Denver should put this park on your favorites list. The rock fins rise up out of the ground at every glance and they are poised at unique angles that just beg to be photographed.

If you can make it out to Roxborough on a weekday, especially during the winter, you may just have the entire park to yourself. There are two trails that I recommend: the Fountain Valley Loop and South Rim.

On the Fountain Valley Loop Trail, go left at the first junction and within half a mile you'll be standing below the towering fins that give Roxborough its name. Frame up the rocks in your viewfinder with a spring flower foreground, an autumn cottonwood background, or the fresh winter snow that covers everything after a storm. The scenery here is fantastic in any season. Take a right at that first junction on the Fountain Valley Loop Trail and you'll have two overlooks for broad scenic shots at your disposal. The Lyons overlook is especially nice, with stunning views to the south.

The South Rim Trail meanders through scrub oak and rocks to a high vantage point where you'll be looking down on the sandstone fins of Roxborough. This is a good trail for spotting elk and deer. Mule deer are very plentiful in Roxborough and seem to know that

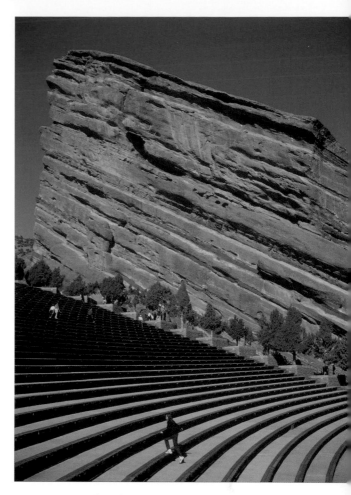

Red Rocks Amphitheater

they are protected, so they all but ignore people. Roxborough State Park does have a strict "stay on the trails" policy that you should do your best to observe when chasing after mule deer photographs.

Directions: Take CO 470 to the Wadsworth exit and go south. Turn left on Waterton Road and go until it ends at North Rampart Range Road. Turn right and continue south past Roxborough Village. At the intersection of Roxborough Park Road, turn left. Take the next right into the park.

I-70, Georgetown to Glenwood Springs

General Description: Colorado's main east/west artery, I-70 is the route most travelers use to cross the state. This route passes through some gorgeous mountain scenery. The road climbs up and over (technically under) the Continental Divide at the Eisenhower Tunnel, then winds past mountains, ski ranges, and another high pass at Vail, before heading through the impressive canyon dug by the Colorado River called Glenwood, and ending up on a high desert plateau that leads to Utah. You could make endless side trips off the interstate looking for photographs, or you can go to my top photo places right off I-70 and accessible by passenger car.

Directions: The start of this section is Georgetown, a small mountain community about 40 miles west of Denver. Just get on I-70 in Denver and head west. All of the places I list in this section are close to I-70. See individual site write-ups for specific directions.

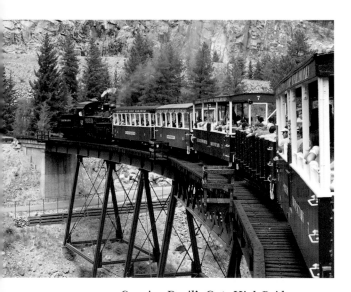

Crossing Devil's Gate High Bridge

Where: West of Denver, reached by I-70
DeLorme Gazetteer: Pages 35–39
Noted For: Ski areas, mountain scenery, wildlife, wildflowers, river canyon
Best Times: January and February for skiing, July and August for summer recreation, November for wildlife
Accommodations and Services: At any of the towns along the interstate, camping throughout the area
Diversions: Skiing, boating and rafting, fishing

Seasonal Influences: I-70 is open all year. Some strong winter storms do create travel restrictions, usually the need for snow tires or chains at the 11,013-foot-high Eisenhower Tunnel. Traffic is a nightmare returning to Denver on I-70 during most summer and ski season Sunday afternoons, and is especially bad after a holiday weekend. Travel this road on any other day and you should have no traffic problems.

Georgetown Loop Railroad (38)

This railroad doesn't go anywhere—it reverses direction and takes riders back where they started—but it's a must ride for train fanatics, kids of all ages, and photographers interested in a bit of Colorado history. Built in 1884 with the hopes of connecting Georgetown with Denver and points east, the line today connects only Silver Plume and Georgetown. It is a great way to see and photograph some of the beauty of the rugged Rocky Mountains. The train itself makes a great photo subject, whether you are riding it or not. Narrow gauge and steam powered, the train sends up great bursts of exhaust steam that give your photos an old-time look. While you're on board, open

cars allow an unobstructed view of everything along the line. Try to get a seat in one of the back cars for the best photo opportunities, especially of the train as it crosses the Devil's Gate High Bridge. The train runs seasonally from the end of May until the first week of October. The best time for photos is in late September when the aspen trees surrounding the tracks turn golden yellow and shimmer in the sun.

Directions: Take I-70 to Georgetown (exit 228), turn right on Argentine Street and follow signs to the Devil's Gate parking area. Passengers can also board at Silver Plume, which is exit 226 off I-70.

Georgetown Bighorn Viewing Area (39)

The Rocky Mountain bighorn sheep is Colorado's state mammal and a great symbol of our mountains. Bighorn are plentiful in Colorado's Rockies, but they are not always easy to see or photograph. They prefer rugged canyons where access is usually difficult at best. The Georgetown bighorn viewing area is one location where photographers can consistently see and photograph these majestic animals with ease.

Show up here in the summer and you'll think I've sent you on a goose chase. The bighorns are around this spot only from about September until April. After that they head into higher elevations.

Georgetown has set up a bighorn-viewing platform on the south side of I-70, complete with information placards and viewing scopes. Don't go there. Instead, if there are sheep in the area, follow the unpaved "frontage" road on the north side of the interstate until you get into a shooting position. Use a beanbag or window mount for your camera and shoot right from your car. The sheep will ignore close approaches by vehicles but any attempt to get out and follow the sheep on foot will result in

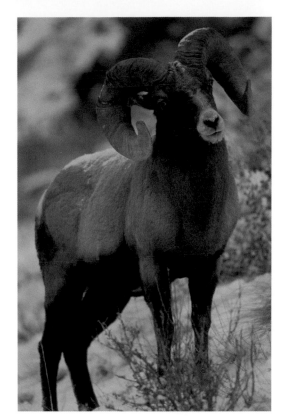

Bighorn sheep

bighorns fleeing the area. A long lens is essential for portrait shots. Bring a zoom telephoto such as a 100–400mm for easy compositional control. November is rutting season and I've watched some big male sheep here bang heads in a dizzying display of dominance.

Directions: Take exit 228 off I-70 and go north at the end of the exit ramp onto an unpaved frontage road that heads east parallel to I-70. Drive until you see the bighorn or until the road ends.

Guanella Pass Road (40)

While a bit rough in spots, the Guanella Pass Road can be driven in any passenger vehicle safely—just drive at a photographer's pace. The road is open all year long and provides

White-tailed Ptarmigan

some of the best access to a Colorado tundra area during the winter (chains required then).

The 23-mile route travels from Georgetown and I-70 to the tiny town of Grant and US 285. Here are some favorite photo spots as you drive north, in the direction of Grant to Georgetown (north).

About 4 miles from US 285 and Grant, the road crosses over an excellent stream where an interested photographer could spend hours exploring the small cascades and mini-waterfalls, especially with clouds over the sun to bring the contrast range down.

Continuing up toward the pass, you'll want to get out a wide-angle lens and explore the great mountain scene, complete with aspen bole fence and wide, sweeping valley, near the Burning Bear trailhead. This is best shot in the morning.

At the pass, you'll have lots and lots of photography choices no matter the season. The scenic views of Mount Evans and Mount Bierstadt look impressive all the time. Remember to find a foreground for your mountain shots; in summer, flowers are the obvious choice. This area blooms with an intense profusion of colors every June and July. Large-flowered alpine sunflowers make perfect foregrounds.

Winter is ptarmigan time. Guanella Pass is the best place to see and photograph these white grouse-like birds anywhere in the state. Finding them is a challenge, but once you do, the photography is easy. I've been surrounded by 20 or more birds here, and they all but ignore me and my whirring camera. They simply don't see humans as a threat. It is a wonderful experience to be among these puffy little birds. Best time is in April when there's still lots of snow and the male ptarmigans get a little red eyebrow for the breeding season.

Heading back down toward Georgetown you'll find a couple of campgrounds (open summer only) if you want to base here for a few days. Near the Clear Lake campground are some big aspen stands and this is where you want to be during late September. Both sides of the road have aspens with some pines mixed in and when those aspen turn golden yellow, wow! You should be able to find a shot at every turn. Pick out an area of yellow aspens with just a few pines for texture and use a long zoom to bring them close. Towards the end of the route you'll wind down a few last switchbacks and end up in Georgetown.

Directions: From US 285 and the town of Grant, go north onto the well-signed Guanella Pass Road. From I-70, exit at Georgetown (228) and wind through downtown, following the signs for Guanella Pass.

Loveland Pass (41)

Loveland Pass is not for the squeamish or inattentive driver. Very few guardrails protect you from the cliffs and steep drops off this winding mountain road. And this is a high pass, too—it tops out just below 12,000 feet. Pay attention, go slowly, and you'll be amply rewarded with spectacular views.

Loveland Pass straddles the Continental Divide with rocky mountains in all directions. Get to the top, park in the ample space, and

wander around; summer or winter, you'll find lots to shoot. In summer, the tundra habitat blows up with color from a variety of alpine wildflowers. A small pond just south of the pass itself acts as a giant reflecting pool for the surrounding peaks. A rough trail encircles the pond and the best views are from around the west side. Calm afternoons are best here. Use some of the water plants or nearby wildflowers for that all-important foreground.

In winter, the place will be buried in snow, and interesting snow patterns make good subjects. (Wandering may be difficult—bring snowshoes.) Photographs of a fresh dusting on the trees as you approach the pass are simply wonderful. Both sides of the pass have stands of pine trees, sometimes growing in perfect triangular clumps just the way photographers like. The pass is open and well maintained all year but, as with all Colorado mountain roads,

strong winter storms can close or restrict access to Loveland Pass.

Directions: Take exit 216 off I-70 and you'll be on US 6, which goes up to and over Loveland Pass.

Dillon Reservoir (42)

This large reservoir stores water for Denver and the Front Range. It has areas that are developed as well as some pristine locations where you "all natural" photographers will be happy. The best way to get around this lake is actually by bike. A wonderful biking/walking trail skirts most of the reservoir and is especially picturesque on the west and north sides. Rent a bike here if you haven't brought one, load your camera gear into a small backpack or the bike basket, and explore the waterfront.

My favorite place for photography here is from the Dillon Marina, where docked

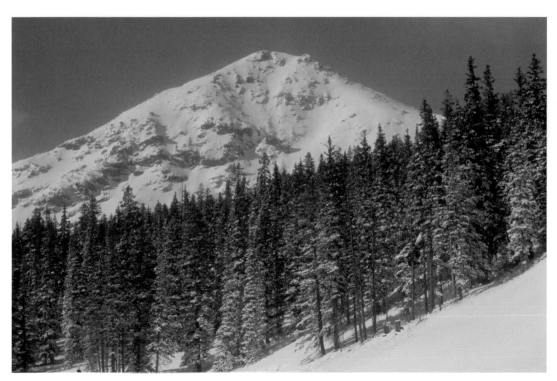

Near Loveland Pass

sailboats make a great foreground for scenic lake and mountain shots. Use a moderate zoom lens to compress the boats and background peaks, making them appear closer together. A polarizer helps remove glare from the surface of the water. Morning is best.

Ride your bike or walk southeast of the marina to where a thin sliver of land hides the town of Frisco for an effective mountain reflection shot. If the water is calm, Buffalo Mountain and Chief Mountain will reflect clearly. Mornings are best here as well.

Photography potential at Dillon Reservoir doesn't stop there. The sailing club has an annual regatta in July, which makes for great sailing photography. From the west end of the reservoir, you'll find good views and photographs of distant Grays and Torreys Peaks; best in the afternoon. There are several camp-grounds around the reservoir and plenty of lodging options in Frisco and Dillon.

Directions: The town of Dillon is at exit 205 off I-70. The town of Frisco can be reached by exit 203 or 201 off I-70. Dillon Reservoir can be seen along this entire 4-mile stretch of I-70.

Breckenridge (43)

Photographers can always find something to photograph in Breckenridge. Summers mean flower-filled meadows, festivals, and streets full of activity. Winters bring skiing, holiday lights, and more skiing.

In any season, stroll Main Street for some great shooting opportunities. Snap on a moderate telephoto lens and, in summer, aim your camera at reflections in windows, still-life displays, or the cultivated flowers that grace every window box. If you visit in winter, walk the

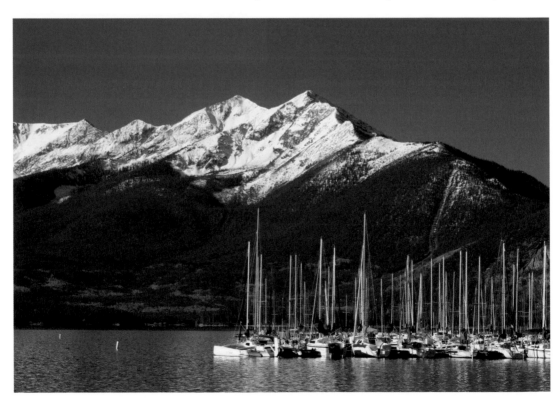

Dillon Marina

Snowmobiling at Shrine Pass

streets at dusk when the twinkling lights plus the twilight sky combine for moody and romantic pictures.

Also in the winter is skiing and snowboarding action photography. When skiing and taking photos, I stuff a small compact digital camera into an inside jacket pocket and pull it out when a likely scene presents itself. My favorite skiing shots at Breckenridge are at the terrain park, where experts show their amazing acrobatic aerial maneuvers. Get about halfway down and set up off to the side and out of the way of one of the big ramp features. Photograph as skiers and snowboarders launch themselves into air flips, multitwists, and midair turns. A big blue Colorado sky is best for this type of action photography.

Non-skiers can get some great skiing action and mountain scenic photography at Breckenridge. Take a non-skier gondola ride as high as is allowed and frame up the snowcapped peaks in all directions. Use some snow-flecked pine trees for a natural foreground element or a colorful skier for a scale element. Other non-skier winter activities with good photography potential in Breckenridge include snowmobiling, dogsledding, and sleigh rides (www.snowmobilecolorado.com, www.tigerruntours.com, or www.nordicsleighrides.com).

Directions: The town of Breckenridge is off CO 9. Take I-70 to exit 203 and go south, or take US 285 south to Fairplay and go north on 9.

Shrine Pass (44)

Shrine Pass is famous for summer wildflower displays. Visit here in June or July and you'll be able to pretty much plop yourself down anywhere, snap on a macro lens, and photograph Colorado wildflowers all day. If the sun isn't diffused by some cloud cover, use a hand-held diffuser or umbrella to shade the flowers.

During the magic hours just before sunset, head for the easy Shrine Ridge Trail. Hike

Hanging Lake

along until you find a nice grouping of flowers to use as a foreground for expansive shots looking southeast into the Gore Mountain Range. If the foreground you've chosen goes into shadow while some nice light still exists on the background peaks, use the appropriate split-neutral density filter or my two-shot exposure-blending digital technique to balance the overall exposure.

The Shrine Pass Road is a rough dirt road. Passenger cars are fine, but I'd recommend taking a high-clearance vehicle. During the winter, the road is closed to cars but the entire area is a snowmobile and cross-country skiing playground. Photograph these winter sports either by participating yourself or by snowshoeing along the trails until you find the action.

Directions: During summer, take I-70 to exit 190 and follow the dirt road northeast to the pass. In winter, the parking area at exit 190 off I-70 is the start of the snowmobiler's playground.

Hanging Lake (45)

This is the longest, most strenuous hike in this book. First, the bad news. This moderately dif-ficult hike is 1.2 miles long and very steep. You'll definitely want to bring as little equipment as possible, but don't leave your medium telephoto lens behind—you'll need it. Now, for the good stuff. Even on a hot summer day, this area is cool from the forest shade. The trail follows a gorgeous stream where photographers should be able to meander, find photographs, and forget the fact that they are walking uphill. Once you get to Hanging Lake, you'll thank me for sending you there—the place is simply fabulous.

Shoot the cascading waterfall at the half-mile marker. A moderate telephoto lens comes in handy here for picking out details that you find interesting. Use a longer shutter speed to get that "cotton candy" look to your shots.

Just before reaching mile marker 1, watch for the hillside of moss-covered rocks and falling water reminiscent of the Pacific Northwest. Again, use a moderate zoom to photograph details in the scene. Use your polarizing filter to eliminate glare and increase the saturation of the green colors.

After a very steep section, you'll be at Hanging Lake. After catching your breath, snap on a wide-angle lens and explore this lake that seems to float above the surrounding cliffs. The cascading streams filling the lake from the far side add to the mystique. This lake looks best when some clouds diffuse the sun a bit or when the sun drops below the mountains to the west. You'll want to shoot this overall scene during these lower contrast lighting conditions. My favorite time to visit is late spring when the trail is snow-free but the runoff filling the lake still has a good flow.

Directions: From westbound I-70 take exit 121 and backtrack eastbound to exit 125, which takes you to the Hanging Lake trailhead. If you are eastbound on I-70, just take exit 125. Note that there is no return to eastbound I-70 from the Hanging Lake exit so you must drive west,

take another exit, and turn around if heading east.

Glenwood Canyon (46)

Glenwood Canyon is a deep, high-walled canyon carved by the Colorado River. The interstate winds along at or just above river level, twisting and turning, so that I want to photograph the road itself every time I drive this way. However, since the road is an interstate, pulling over when you see a good composition is just not possible.

There are a few vehicle exits in the canyon and a great biking/walking trail, which follows the path of the interstate. This is how to best photograph Glenwood Canyon. Leave your car at exit 129 (Bair Ranch) and either bike or walk east from here. Travel along looking for colorful canyon walls reflected in calm river pools, or photograph a section of the highway itself as it winds through the canyon. The Union Pacific Railroad and Amtrak also come through here and can make for great subjects as the trains come out of tunnels and around river bends.

Near exit 125, some calm river sections reflect the canyon walls. If you want to do some action photography, visit in the summer and get off the interstate at exit 123. Whitewater rafters and kayakers ply the waters here in search of thrills. Use a long lens to bring the action close.

Directions: Follow I-70 to the exits listed above. Note that exits 123 and 125 have no return to I-70 eastbound so you must drive west, take another exit, and turn around if heading east.

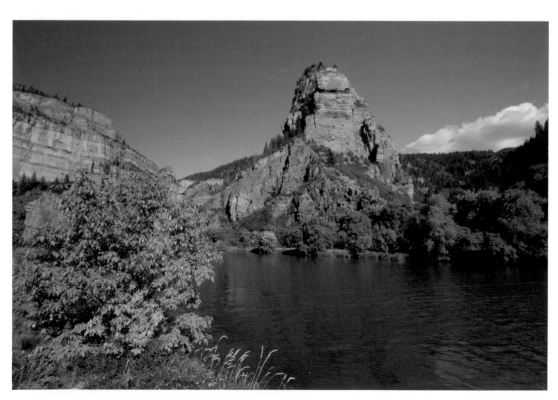

Glenwood Canyon

CENTRAL COLROADO ROCKIES

Carbondale

Aspen

McClure Pass (51)

Maroon Bells

(133)

(82)

Tennessee Pass

Turquoise Lake (62) (63)

Leadville

(24)

Independence Pass Road (47)

(50)

Ashcroft Ghost Town (49)

Paradise Basin & Pass Road (48) (56)

Gothic Road (55)

Mount Elbert Twin Lakes area (64)

Forest Road 738 (59)

Crested Butte (57)

Lake Irwin (58)

Forest Road 730 Ohio Pass

(92)

Black Canyon of the Gunnison National Park

(61)

Curecanti National Recreation Area

Cottonwood Pass (66)

Forest Road 344 (67)

Along the Arkansas River (65)

Buena Vista

(285)

Arkansas River

Salida

(285)

(60) **Gunnison**

(149)

(50)

(550)

Lake City

25

Pikes Peak (52)

Garden of the Gods (53)

Manitou Springs

Colorado Springs

(54)

Mueller State Park

(24)

Eleven Mile River

Canon City

(50)

N

0 25

miles

III. Central Colorado Rockies

Aspen Area

General Description: This area is famous for its premium ski area and upscale town of Aspen, which attract the rich and famous from all over the world. Regular old outdoor and scenic photographers will find priceless scenery and awe-inspiring views to capture here. Smack dab in the middle of the Colorado Rockies, jagged peaks rise above pristine valleys, and vistas from mountain passes go on forever. The ruins of ghost towns where dreams of gold and glory died out provide us with reminders of the past. Today, this area is home to enough aspen trees to boggle the mind and, in autumn, when they turn to gold, photographers can fancy themselves among the rich as they reap the bounty of this astounding section of Colorado.

Directions: The town of Aspen is the center of this area. To reach Aspen take CO 82 south from Glenwood Springs, leaving I-70 at exit 116. Alternatively you can travel northwest on CO 82 from US 24 just south of Leadville.

Seasonal Influences: From Glenwood Springs to Aspen, CO 82 is open and well maintained all year. CO 82 is closed at Independence Pass from about mid-October until May. See individual site write-ups for additional seasonal information.

Aspen Town and Ski Areas (47)

The town of Aspen does have lots of interesting street scenes and expensive shops where a photographer can get some still-life shots. Winter brings out dazzling holiday light displays and the chance that you might spot a famous actor, musician, or Olympic star window-shopping right next to you.

Where: West-central Colorado, reached by CO 82

DeLorme Gazetteer: Pages 46–47

Noted For: Mountain scenery, fall color

Best Times: July and August for summer recreation, late September and early October for fall color

Accommodations and Services: Town of Aspen; towns of Carbondale, Glenwood Springs, or Leadville for more reasonable prices; camping throughout the area

Diversions: Festivals in Aspen, skiing, hiking, mountain climbing, and wineries near Paonia

However, my preference when visiting Aspen is to get out of town and hit the slopes with a compact camera in a jacket pocket. Whether you ski or not, the mountains around Aspen are a photographer's heaven. Gondolas whisk people to the tops of mountains summer and winter. If you do ski, get a lift ticket at any of the four ski mountains surrounding Aspen and photograph the ski action and gorgeous scenery. Blue-sky days show off this section of Colorado best.

Non-skiers should take a ride up the Silver Queen Gondola to the very top of Aspen Mountain. Breathtaking mountain views await you as well as the best view of town you'll ever see. Get up here in the morning when the winter sunbathes the surrounding high peaks in beautiful side light. Bring a moderate telephoto lens in order to zoom in on impressive distant peaks. Take your time exploring, enjoy lunch at a mountain restaurant, snowshoe or hike the trails, and photograph all day.

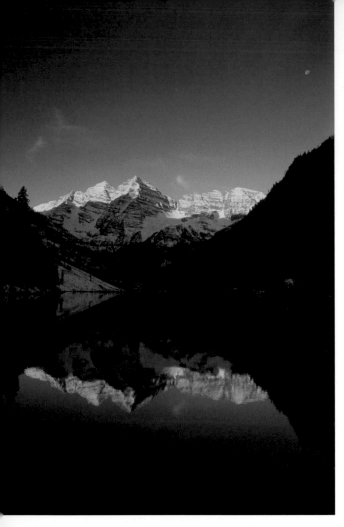

Maroon Bells from Maroon Lake

pictures here you shouldn't be discouraged from doing the same. On the contrary, this is so often photographed because it is so spectacular, and you should come here and shoot these scenes too.

From Maroon Lake, the two pyramid-shaped peaks of Maroon Peak and North Maroon Peak reflect perfectly. Set your tripod up on the northeast shore of Maroon Lake at sunrise and hope for calm water. The morning light takes some time to fill the scene in front of you completely, so have some patience; otherwise you'll be dealing with contrast problems.

During the summer, displays of wildflowers should make finding a foreground easy. In autumn, use some rocks or the curving shoreline as your foreground. Autumn is the best time to be here because the huge stands of aspens that fill the valley provide golden colors to the already glowing scene. However, every other photographer in the world seems to be here then, too. If you'd like to avoid some of the inevitable crowds, take the easy hike past Maroon Lake to Crater Lake. The peaks are a lot closer from here and you'll need your widest-angle lens in order to show all the beauty. In summer this 1.5-mile trail to Crater Lake may take several hours to walk because you'll be distracted by countless wildflowers. During autumn the same thing could happen because of all the aspen trees.

Automobile access from mid-June through September from 8:30 AM to 5:00 PM is restricted and visitors must take the shuttle bus from Ruby Park in Aspen. Now, of course, if you're reading this book, that means you are an above-average photographer and would never be caught getting started on scenic photos at the late hour of 8:30 AM. Just get up and get going well before that time and you can drive your own vehicle to Maroon Lake. Winter access is restricted to snowmobiling or cross-country skiing on Maroon Creek Road.

Directions: Aspen is on CO 82. The Silver Queen Gondola is at the base of Aspen Mountain Ski Area. Take CO 82 to South Hunter Street and go west to the corner of Durant and South Hunter.

Maroon Bells (48)

These mountain peaks may well provide the most fabulous views in all of the Colorado Rockies. The view of the Maroon Bells from Maroon Lake is also rumored to be Colorado's most photographed location. However, just because lots of other photographers have taken

Directions: From the roundabout just west of Aspen, off CO 82, take the Maroon Creek Road (Forest Road 125) southwest about 10 miles to Maroon Lake.

Ashcroft Ghost Town (49)

Ashcroft and Aspen both had their beginnings in mining and, during the early 1880s, Ashcroft was actually bigger than Aspen. When the railroad went to Aspen instead of Ashcroft, the latter town slowly died. Now it's a true ghost town. The main street (now a boardwalk) is dotted with just enough weathered buildings with false fronts to give a sense of what the town was like in its heyday. I love photographing Ashcroft because the buildings are weathered just enough, without being piles of rubble.

Just to the left of the boardwalk's start is an old ore wagon that makes a great foreground element for your shots of Ashcroft. Use a wide-angle lens and get close to make the wagon appear bigger than it is. The overall view and photos are also good from the far end of town where the hotel dominates that area. Look for macro details here as well. Simple things such as doorknobs and rusted hinges can make good photos at ghost towns. Ashcroft is open all year but is best during the summer, when flowers fill the surrounding meadows, and all the trees are green. The historical society charges a daily fee for summer visitors.

Directions: From the roundabout just west of Aspen, off CO 82, take the Castle Creek Road (Forest Road 102) south about 11 miles to Ashcroft.

Independence Pass Road (50)

This is one of the highest, most impressive mountain pass roads in all of Colorado and a must-see site for photographers. I'll mention the highlights of this road as it travels from east

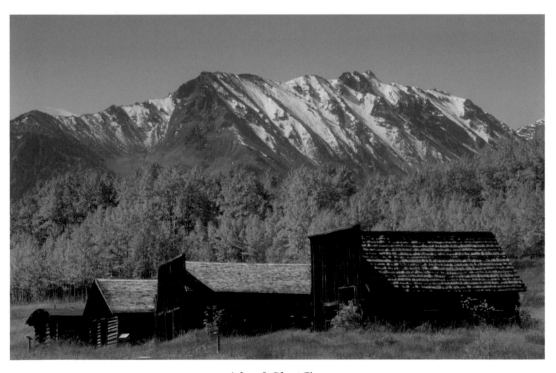

Ashcroft Ghost Town

to west. This road is closed from about November 1 (or earlier if snows are heavy) until sometime in May.

Let's start from mile marker 75 on the east side of the pass. Watch for an old red barn and picturesque wooden windmill on the south side of the road. Photograph this barn with late afternoon or early evening light on it, using the windmill and antique car as secondary elements.

Continue up the pass to mile marker 65, where a handy pull-off is a safe place to stop and photograph the view to the southeast. Here I'd actually use the road as a scale element and for a sense of place. The distant mountain views are extraordinary.

Up at the 12,095-foot pass, you'll have 360-degree views and snowcapped mountains as far as the eye can see. Summer alpine flowers are prolific here and should make macro enthusiasts very happy. A couple of small alpine tarns (lakes) at the pass will reflect any sunset colors in the sky. Use the ponds as foregrounds for your mountain view shots.

Over the pass, at mile marker 60 is another pull-off with impressive views, this time to the east. Again, use the road as a leading line for your mountain shots. This view is best in the early morning. Continuing down toward Aspen, you'll come to Independence, an abandoned mining town from the 1880s. The old buildings here can make good framing elements for your scenic area shots. This ghost town is in the best light during the evening.

Continuing on down CO 82, you'll start passing mile after mile of aspen trees. Visit here during fall color season and you'll agree that no words can describe how gorgeous this section of highway is. When photographing aspens under clear skies, get into the aspen forest and look up to emphasize the blue and yellow together. If skies are cloudy, find a high vantage point and look down on aspen stands, placing them against pine tree hillsides or lush valleys.

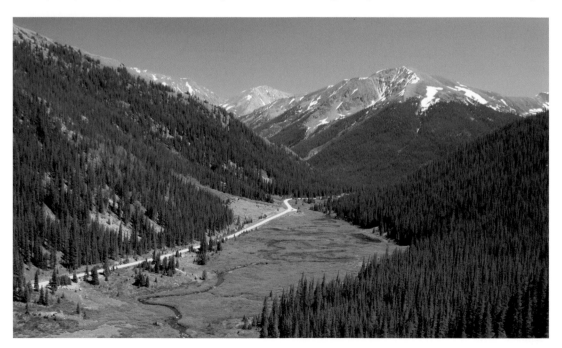

From mile marker 65

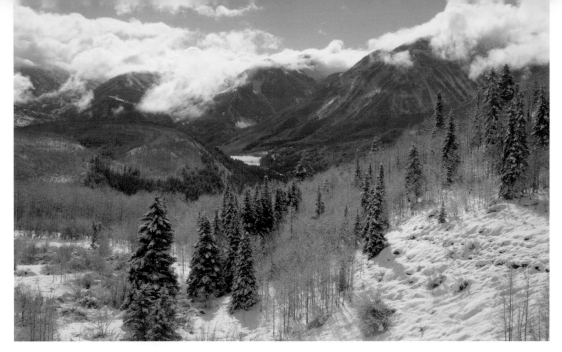

McClure Pass, early winter

Directions: From the west, take CO 82 southeast of Aspen to the pass. From the east, south of Leadville, take US 24 south to CO 82 and go west.

McClure Pass (51)

Because of this pass's lower elevation (8,755 feet), aspen trees are the dominant feature here, and I do mean dominant.

Let's start on the south side of the pass, on CO 133, and head north. Heading up toward the pass, the road skirts the north fork of the Gunnison River where lots of cottonwood trees provide color well into October. The Paonia State Recreation Area has some potential scenes with a reservoir and sparse aspens and cottonwoods lining the side canyons nearby. Look for views across the water into the Ragged Mountains.

The real photography begins about 5 miles below McClure Pass. This is where one of the largest stands of aspen trees in Colorado starts and the tree spectacle doesn't stop until a few miles down the other side. Get here in late September when all these aspens become golden, and all your scenic photography dreams might come true. Stop anywhere along here (use pull-offs for safety) and for compositions in this display of nature's majesty.

Just north of the pass is a wide-angle scene straight from an artist's palette. Point your camera south into the Raggeds Wilderness, frame up some aspen trees for foreground, and show the beauty that is the Colorado Rockies. This scene is glorious in June after the aspens leaf out, in prime fall color time, and also after a fresh snow in the middle of the winter. McClure Pass should be at the top of your photo list, especially for Colorado fall colors. The pass is open all year with possible temporary winter storm closures.

Directions: McClure Pass is west of Aspen and south of Glenwood Springs. Take I-70 to Glenwood Springs, take exit 116, and go south on CO 82. Take CO 133 south in Carbondale.

Colorado Springs Area

General Description: Colorado's second largest metropolitan area is nestled right below the Rocky Mountains and, because of its location, has lots to offer the outdoor photographer. Colorado's best-known mountain, Pikes Peak, is here, as are several very scenic parks. Great weather is the norm in the Colorado Springs area, with sunny skies most of the year. I like to visit this area especially during the winter, when fresh snow blankets Pikes Peak and the city's museums and excellent zoo provide midday activities to keep me warm.

Directions: Colorado Springs is 60-some miles south of Denver on I-25. From the west or east, US 24 also passes through Colorado Springs.

Seasonal Influences: I-25 and US 24 are open and maintained all year with occasional local closures from heavy winter storms. According

Pikes Peak from Crystal Creek Reservoir

Where: East-central Colorado, reached by I-25 or US 24

DeLorme Gazetteer: Pages 62–63

Noted For: Colorado fourteener with road to top, mountain scenery

Best Times: June for access to snowcapped peaks, midwinter for snow scenes

Accommodations and Services: Town of Colorado Springs, camping throughout the area

Diversions: Colorado Springs museums, zoos, downtown area, and festivals

to the management at the Pikes Peak toll road, this road is open all year depending on conditions; however, for photographers, it's best to visit this fourteener during spring and summer for wildflowers and during fall for aspen colors. Garden of the Gods is open all year.

Pikes Peak (52)

Pikes Peak is known locally as "America's Mountain" largely because Katharine Lee Bates penned "America the Beautiful" after visiting the summit. The mountain rises dramatically to the sky and can be seen from all around Colorado Springs. It is much more photogenic when snow covered.

This is one of two fourteeners in Colorado that have roads to the top. (Mount Evans is the other.) The toll road has over a hundred curves on its way to the summit—so pay attention! It also has lots of pull-offs and potential photo spots. The Crystal Creek Reservoir at mile 6 offers the best views of Pikes Peak. On calm afternoons the mountain will reflect perfectly in the water. This area has lots of aspen trees as well, and should be visited and photographed in early October for fall color.

During the summer, roadside flowers grow in profusion along the toll road. From mile marker 14 to the summit, pay attention for fields of alpine flowers, especially in late June and July. Watch for the occasional bighorn sheep, marmot, and pika as well. At the summit, the views extend for a hundred miles on clear days. The toll road is open year-round, weather permitting. There is a per person fee to drive the road. This fee is significantly lower if you want to go only as far as the Crystal Creek Reservoir.

Directions: From Colorado Springs go west on US 24 to the well-signed Pikes Peak Toll Road entrance.

Garden of the Gods (53)

Interesting red rock formations jutting into the sky and a Pikes Peak background await you here. Scenic opportunities are tremendous. At sunrise, the rock formations glow from unobstructed low-angled light. Garden of the Gods has 15 miles of trails to wander and shoot from. This is an easy place to find shots—the rock formations are everywhere. Just be sure to compose your scenic shots with foreground, middle ground, and background. Popular foregrounds include the natural window on the Siamese Trail, the "Kissing Camels," and Balanced Rock. Pikes Peak is the most obvious background, and it looks best when snow covered. My favorite time to visit is just after a winter storm moves through. A fresh dusting of powder on the red rocks makes for magical photographs of this area.

Directions: From I-25 take exit 146, go west 2.5 miles, turn left on 30th Street to park entrance.

Mueller State Park (54)

This park is a hiker's paradise. There are over 50 miles of trails to explore here. Wildlife,

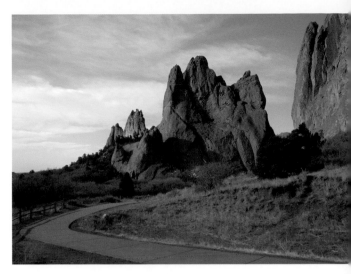

Garden of the Gods Trail

summer flowers, and fall aspens, as well as scenic rock outcroppings and views of Pikes Peak, are all potential subjects here. Many of the trails attract horseback riders and mountain bikers. Adventure photographers should find a scenic location where riders pass by, and photograph the action.

My favorite area at Mueller State Park starts at the Grouse Mountain trailhead. Grab a camera and a daypack and walk around this area's trails for an afternoon. In late September, the aspens will be golden yellow, Pikes Peak should have a fresh dusting of snow, and the views of the mountain through the trees are excellent. You could walk as far as Cahill Pond on an easy 2.5-mile loop hike, where wildlife (especially elk) come to drink and the aspen groves splash color in every direction. Mueller State Park has great camping and facilities and would be a good base for photographing all of the surrounding area. Be prepared with a state park pass or pay a daily fee.

Directions: From Colorado Springs take US 24 west to CO 67 and go south to the park entrance.

Crested Butte Area

General Description: I love Crested Butte. This town and surrounding area has it all for photographers—great scenery, outdoor sports, national parks and recreation areas, Colorado's largest body of water, and photo opportunities everywhere. The town itself is everything that a Colorado mountain town should be: surrounded by mountains, friendly, laid back, and unpretentious. The surrounding area is full of pure Colorado wonderment no matter the season. Winter, of course, means skiing, and the Crested Butte ski resort is delightfully uncrowded and a favorite for intermediate skiers. Summers in Crested Butte are simply glorious, with one main draw: flowers, flowers, and more flowers. Crested Butte is the wildflower capital of Colorado—come here in late June/early July and the spectacular displays of wildflowers will simply put you in awe. I don't know that it's possible to pack any more flowers into one area. Add to the flowers the colorful sunrises and sunsets over Blue Mesa Reservoir and the

> **Where:** Central Colorado, reached by CO 135 off US 50
> **DeLorme Gazetteer:** Pages 56–58, 68
> **Noted For:** Wildflowers, mountain scenery, fall color, large reservoir, and deep canyon
> **Best Times:** July for wildflowers, summer for watersports, and mid-October for fall color
> **Accommodations and Services:** Towns of Crested Butte and Gunnison, camping throughout the area
> **Diversions:** Skiing, boating, fishing, and festivals in Crested Butte

gorgeous and deep canyon at Black Canyon of the Gunnison.

Directions: Crested Butte itself is reached by driving north on CO 135 from the town of Gunnison. Other areas in this section are west of Gunnison off US 50.

Seasonal Influences: The road to Crested Butte is open and maintained all year. Some of the spur roads I've written about are closed in winter. These include the road to Lake Irwin, the Kebler and Ohio Pass Roads, the Gothic Road north of town, and the Paradise Basin and Pass Road. All of those sites are best in spring and summer anyway for their wildflower potential. The autumn season is good all throughout this region as well and all roads stay open in fall until a major snowstorm closes them for the season. Road information can be found at www.dot.state.co.us.

Gothic Road (55)

Travel this road with caution. A photographer could easily get scenic overload here and run out of film, memory card space, battery power, or time. This road in early July will blow your

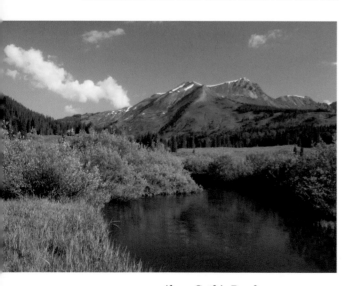

Along Gothic Road

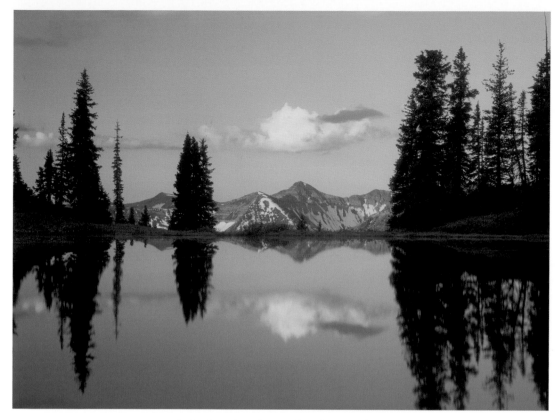

At the junction of Forest Road 519 and 734

mind. Also called County Road 317 (CR 317), this road heads north out of Crested Butte and cruises along a gorgeous stream, passes mountain after mountain, skirts a pretty little lake, and will keep you busy for a long time.

The road isn't paved, but the dirt surface is smooth and passable by passenger vehicles all the way to Schofield Pass. Other than the obvious flower foregrounds along this road, you might consider mountain reflections and colorful rocks; park your car and wander along the East River to find them. Emerald Lake, toward the end of Gothic Road, also has some photography potential. Summer is the best time to be on this road but, in September, the changing aspens also provide outstanding opportunities.

Directions: From Crested Butte and CO 135, take CR 317 north until the scenery forces you to stop and shoot.

Paradise Basin and Pass Road (56)

For this road, a 4-wheel drive is recommended, but I've seen plenty of two-door sedans back here. As long as your vehicle has enough clearance you should make the drive to this very scenic location. Again, flowers are a main subject here and they grow in abundance in July.

Save at least a morning's shooting for the great mountain reflection you'll see at the junction of Forest Road 519 (FR 519) and Forest Road 734 (FR 734). This shot, which looks west into the Ruby Mountain Range, is best during early morning. Look for the small pond

Ruby Mountain Range

right at the junction of the two forest roads. Position your camera low to the ground and at water's edge. A polarizer will help improve the sky at this hour. Expose for the distant peaks and let your foreground trees turn to silhouettes.

Directions: From CR 317 at Schofield Pass, head west on FR 519 until it intersects with FR 734 (about 4 miles back).

Lake Irwin (57)

This little lake offers up one of the prettiest mountain reflections in the Colorado Rockies. A small lodge and a couple of rentable lakeside cabins, as well as a forest campground, are available if you wish to spend some time at Lake Irwin. Despite the buildings, the lake still looks and feels mostly natural.

Set yourself up along the southeast side of the lake for sunrise and early morning reflections. Have a friend rent a colorful canoe and take it out into the lake in order to add a great foreground and scale element to your lake shots.

There are also some good panoramic mountain views to the south from the campground. Lake Irwin is best in the summer, but some of the cabins are available all year. Winter access is by cross-country ski or snowmobile only.

Directions: From Crested Butte, take Forest Road 12 west toward Kebler Pass. The Lake Irwin Road is Forest Road 826 and heads north off 12.

Forest Road 730/Ohio Pass (58)

The road to this pass is one of my favorite places for photographing farm and ranch scenes. Most of the 19 or so miles of Forest Road 730 (FR 730) are paved, and traffic is light. Drive slowly and stop when something catches your eye. Look to photograph bright red barns, horses in golden pastures, antique tractors, and other agrarian scenes as you travel toward Ohio Pass.

Eventually you'll cross into the Gunnison National Forest and the scenes become natural. Summer wildflowers bloom along the road and you'll pass through some large stands of aspen

trees that look their best in June after leafing out or in late September when golden. A great scenic spot presents itself about a mile south of Ohio Pass. A huge aspen forest stretches out beautifully and the West Elk Mountains catch early morning light. Use a split neutral density filter or my two-shot digital technique to control the high contrast that will probably be present at sunrise.

Directions: From Gunnison travel north on CO 135 about 3 miles to the junction of FR 730. Go northwest on 730 to the pass.

Forest Road 738 (59)

This road skirts the base of Mount Crested Butte, where summer wildflowers create amazing beauty. During a good flower year, the hillsides will be covered in mule's ears and nodding sunflowers. Early July is the best time to drive this road. Find yourself a vantage point where you can look west into the Ruby Mountain Range and use some of those flowers for a good foreground to your mountain shots. This works best in the early morning. After the sun gets higher in the sky, there are still lots of shots from along this road. Get low and close to a group of tall sunflowers and place them against a deep blue Colorado sky. Use a macro lens to concentrate on flower close-ups or the insect life that is attracted to all these flowers. As a bonus, along this road, there is a great 19th-century farm scene near mile marker 3. Shoot the rustic barn using the dirt road as a leading line.

Directions: From CO 135, 1.5 miles south of Crested Butte, turn east onto Forest Road 738 at the sign marked THE CLUB AT CRESTED BUTTE.

Curecanti National Recreation Area (60)

When the Gunnison River was dammed, Blue Mesa Reservoir and Curecanti National Recreation Area (NRA) were the result. Blue Mesa Reservoir is Colorado's largest body of water. This is a summer boating and camping playground. Photographers should come here for boating shots, sunrises and sunsets, and the occasional reflection scene.

One of my favorite sports photography locations is at the windsurfer beach near mile marker 139. On any breezy summer weekend, windsurfers will be plying the wind and waves near this area. Use a long lens from here and practice your panning and blurring techniques.

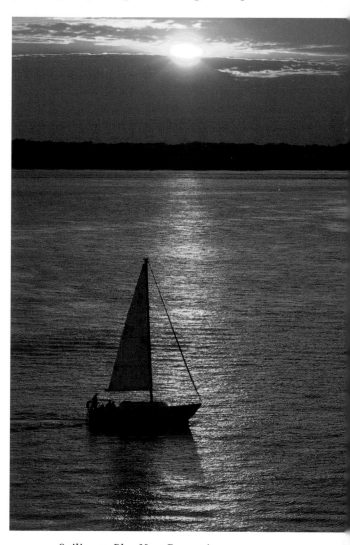

Sailing on Blue Mesa Reservoir

Tomichi Point

<div style="text-align: right">© Shelly Mammoser</div>

Scenic photographers should head to the overlook at mile marker 136 for the best view in all of Curecanti NRA. From here, the Dillon Pinnacles rise above the water and resemble an alien landscape feature. At sunrise the pinnacles catch warm sunrise light and are sometimes reflected in Blue Mesa's waters.

A good place to watch the sunrise and sunset is at the Lake Fork Marina, where boats heading out or coming in, plus colors in the sky, add up to great shots. Lots of campgrounds and fishing opportunities are all along the reservoir, for those who want to stay and play awhile.

Directions: Take US 50 west from Gunnison to the national recreation area, which extends along the highway for some 30 miles.

Black Canyon of the Gunnison National Park (61)

This place is a refreshingly uncrowded gem in the national park system. The canyon is deep, narrow, and full of stunning views. Two winding, seasonally open rim drives provide access to most of the park's overlooks and features.

Drive along and stop to check out every overlook, pull-off, and named viewpoint. Pick a spot and wait for sunset or sunrise light. The canyon lies at a diagonal to the rising and setting sun, so early and late light means long, deep shadows that should be used to your advantage in giving a three-dimensional feel to your photos. Watch for contrast issues and solve problems with contrast by using my two-shot digital technique. Split neutral density filters have limited use here, as the differential between light and dark areas is rarely a straight line.

Tomichi Point on the south rim and Big Island View on the north rim are two good spots for photographing the sunrise. Sunset vantage points are everywhere: Pulpit Rock, Chasm View, and Sunset View on the south rim and the Narrows View and Chasm View on the north rim are favorites of mine.

Many of the view points have short trails to the overlooks. By far, my favorite is the short walk to Gunnison Point. This trail starts from behind the visitor center on the south rim. Late afternoon light from this point is awesome. Also come here if skies are cloudy on the day you're visiting. The massive trees growing right from the sheer canyon walls across the way make great cloudy day photo subjects. During the winter, the south rim road is plowed up to this point and a fresh dusting of snow on the trees would create a bit of magic for these shots.

All of the north rim road is closed to vehicles in winter. There are no lodging facilities in the park, other than the three campgrounds, so those wishing to spend some time here need to tent or RV it. Campgrounds are also closed in winter.

Directions: To reach the south rim take US 50 east from Montrose to CO 347 and go north 7 miles. To reach the north rim, take CO 92 southeast from Hotchkiss to the well-signed North Rim Road.

US 24, Tennessee Pass to Buena Vista

General Description: US 24 is an east/west highway that actually runs north and south through a very scenic section of the central Colorado Rockies. The roughly 30-mile section of US 24 from Leadville to Buena Vista is a designated scenic highway, called the "Highway of the Fourteeners" because you'll pass 10 peaks that rise to more than 14,000 feet along a 19-mile section of this road. Those tall snow-capped peaks, including the state's highest (Mount Elbert, 14,433 feet), line the highway and beckon scenic photographers to stop, explore, and shoot. This area is dotted with lakes and reservoirs, adding mountain reflections to

the mix of tempting shots. Action sports make a big impression here, too. Our nation's fourth longest river—the Arkansas—begins in these mountains and attracts whitewater junkies and those who would photograph the action.

Directions: From the north and I-70, US 24 starts just west of Vail at exit 171. From there it is approximately 20 miles south to Tennessee Pass and the start of my photography descriptions. From the east, the designated scenic highway starts at Antero Junction, where US 285 and US 24 intersect.

Seasonal Influences: US 24 is maintained all year long with possible short-term closings due to winter storms.

Tennessee Pass (62)

Tennessee Pass goes over the Continental Divide at an elevation of 10,424 feet—moderately high as Colorado passes go. While many passes get you above tree line for 360-degree views, Tennessee Pass is in the midst of aspen trees—which could be great subjects themselves if you time your visit with peak fall color (late September). Ski Cooper ski resort is here,

Snow and aspen tree

and a winter visit, some skis, and a camera would get you some nice winter views. During the spring and summer, as you travel south over the pass, you'll get impressive views of Mount Massive and Mount Elbert to the south of the highway. Use the old shack just south of the pass or one of the old barns down in Tennessee Park as an interesting foreground element for your mountain shots. Tennessee Pass is open all year.

Directions: Tennessee Pass is about 20 miles south of I-70 and about 8 miles north of the town of Leadville directly on US 24.

Turquoise Lake (63)

Photographers will find snowcapped mountain reflections on all sides of this lake from anywhere along its perimeter drive, depending on the time of day and season. Turquoise Lake is surrounded by pristine pine forests, which cover all of the lake's hillsides. Easy access and camping facilities here or a short drive from the town of Leadville add to Turquoise Lake's appeal.

Starting from the southeast corner of the lake, County Road 9 (Forest Road 105) skirts the edge. The first stop for photographers should be the Abe Lee fishing access point. From here, there are great views to the east into the Mosquito Range and, if the water is calm, the mountain reflections are also good.

Back on the perimeter road, head west along the lakeshore and watch carefully for a great view to the west as you round a bend. The trees block lots of the scenery around here, but you'll know the opening I mean when you see it. Find a pull-off and photograph this awesome view; it's best in the morning. Continuing west, watch the hillsides to your left for numerous mountain streams that present a photographer with great little cascades and flowing water shots.

Past the May Queen campground, the peri-meter road curves around the west end, then heads uphill and east. You'll pass some established viewpoints with signed "photo spots," but these are a tease at best. In fact, all along the north shore (including those viewpoints) you'll be tantalized by fleeting views of Mount Elbert, Mount Massive, and the gorgeous lake nestled in its deep valley. Most of the views are obstructed by lodgepole pines, but if you can find an opening for your camera, the photos should be spectacular.

The last stop and a great morning location is the Tabor boat ramp on the northeastern side of the lake. Get here early for a calm lake and both Mount Elbert and Mount Massive should be reflected. Use some lakeshore rocks or a flowering lupine bush for a foreground.

Directions: From Leadville and US 24, turn west onto County Road 4. Eventually this turns into County Road 9 and this road and County Road 9C are the circumference roads around the lake.

Mount Elbert/Twin Lakes Area (64)

Mount Elbert is the highest mountain in Colorado, and at 14,433 feet it beats next highest Mount Massive by a whopping 12 feet. Both mountains are in the same range and can be viewed and photographed from lots of places around Leadville. South of town, exit US 24 onto County Road 24 (CR 24) and head west/south. Here you should slow down and take in panoramic views of both these high mountains. As the road winds up through some small foothills, glimpses of both peaks tempt the camera. Continue up the road to an obviously manmade reservoir called "Mount Elbert Forebay." Early mornings spent here can lead to some wonderful reflection shots of Mount Elbert and other tall mountains stretching to the south. Follow CR 24 down past Lakeview campground and you'll wind up on CO 82, which skirts the northern shore of the Twin Lakes.

Twin Lakes are also manmade but the evidence is not as obvious as at Forebay. These two lakes offer a plethora of photo opportunities. Subjects here include mountains and their reflections, with aspen-covered hillsides, wildflowers, strategically placed pine trees, and sailboats for interesting foregrounds.

Deception Point is a fisherman's access area with great morning potential. If the lake is calm, it will be reflecting La Plata Peak and you'll find some wonderful foreground trees by climbing a small hill to the northeast of the boat ramp.

Also along Twin Lakes is Dexter Point, where another boat ramp can be the starting point for morning reflection shots. From the boat ramp, walk west along the Twin Lakes shoreline until you find some interesting foreground rocks for your reflection shots of La Plata Peak, Mount Elbert, and the Continental Divide.

Directions: To get to Twin Lakes, exit US 24 onto CR 24. Alternatively you can take US 24 until the junction with CO 82 (about 14 miles south of Leadville). Head west on 82 until you see Twin Lakes on the left. The Dexter Point area is a well-signed left turn. For Deception Point, exit at the White Star campground/Red Rooster boat ramp area.

Along the Arkansas River (65)

This area is, by far, the best place in the Colorado Rockies to photograph a churning river and all the adrenaline junkies who ride the action. Here are some good spots for photographing the rafting and kayaking action as well as some gorgeous river scenes.

Start at the railroad bridge area 9 miles north of Buena Vista. Take County Road 371 to the east off US 24. Lots of good rapids in quick succession start on either side of the

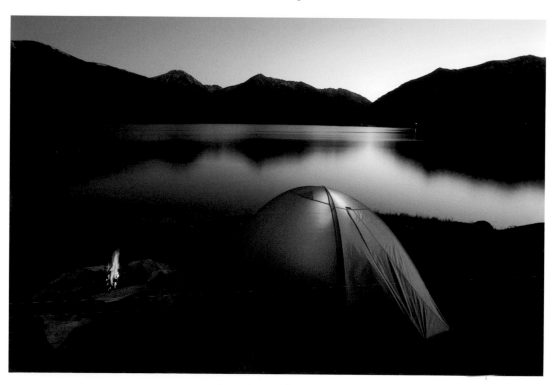

Camping at Twin Lakes

bridge. The best location is on the east side of the river, downstream about 200 yards. Set up on the stream bank or up on a rock where you can see the rafters coming down into the rapids. The best time to be here is when the snow starts melting in late May. Loads of colorful rafts and rafters will hit the rapids along this section with a whoop and a splash. Use a fast shutter speed to stop water drops and excited facial expressions.

The next spot for action is to go east on Main Street from downtown Buena Vista. The town owns the Buena Vista River Park here where kayakers spend hours playing on a big water wave. Set yourself up on shore right near the wave and photograph the kayakers as they surf, roll, and paddle up and down the rapid. Try shooting at about a 30th of a second for just the right motion blur for kayakers.

Next, drive south on US 24 and stay on US 285 past the US 24/285 junction. Drive about 13 miles to Hecla Junction. Turn east onto County Road 194 to its end. This is where the

Buena Vista River Park

Arkansas River comes through Browns Canyon. The canyon is steep walled and beautiful. I'd recommend walking downstream about a half mile for the best rafting action. A big and mean rapid here called "Seidel's Suckhole" provides great scenes for some fast-paced photography. This is where most rafts will flip if the crew has a miscue. The river scenes along this section of Browns Canyon are pretty as well and with a long lens you can get shots of cascades and colorful canyon wall reflections in calmer areas.

Directions: Buena Vista is some 140 miles southwest of Denver. The Arkansas River flows along US 24 north of Buena Vista and along US 285 south of Buena Vista. Follow directions above for individual shooting locations that I recommend.

Cottonwood Pass (66)

This is a stunning Colorado mountain pass that crosses the Continental Divide and provides glorious views that go forever. The road starts in Buena Vista, passes through some development, and then enters the San Isabel National Forest. Once you're into the forest the photographic fun begins. Aspen and cottonwood trees provide the interest at lower elevations, especially in June after just leafing out. The Sawatch Range Mountains provide gorgeous snow-covered backdrops.

The road follows a crystal-clear stream that's been dammed in several places by industrious beavers. Watch the beaver ponds for mountain reflection possibilities. Continue up the winding road into more and more aspens, which offer peak color in late September. The aspens are especially scenic around Rainbow Lake and reflections of shimmering trees in the lake could keep a photographer busy for some time.

Up near tree line, panoramic views begin in all directions. Once you reach the pass itself, park your car and ensure you've got lots of film

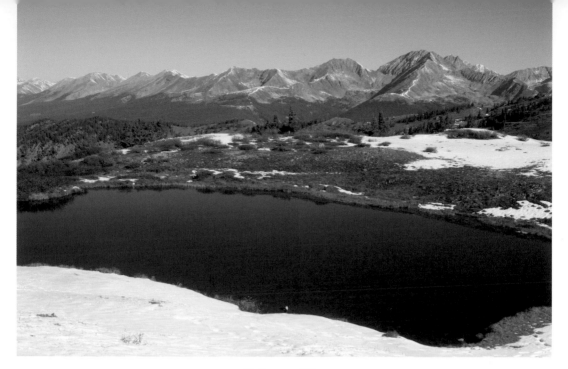

Cottonwood Pass

or digital memory. The scenic views from here extend in 360 degrees and are simply astounding. My favorite shots are down at the little alpine pond 100 yards west of the pass parking lot. Point your camera north from here into the Collegiate Peaks Wilderness, using the pond and some lichen-covered rocks as foreground. This spot is good at both sunrise and sunset.

Directions: From US 24 and the town of Buena Vista, go west on the Cottonwood Pass Road, which is also known as Forest Road 306. Cottonwood Pass is closed from about November 1 to June 15 due to snow.

Forest Road 344 (67)

Photographers interested in shooting Colorado's fall color should keep this road in mind. Shots along this road are best found by pulling over and walking into the forest. The aspens grow tall and straight here and this is one of my favorite places for wide-angle shots of aspens against deep blue Colorado skies.

Put on the widest-angle lens you own and wander the forest looking up for a group of aspen trees devoid of dead or leafless branches. You're trying to show the beauty of yellow leaves against blue sky. Once you find a potential spot, lie on the ground or brace yourself against a straight trunk, maximize your depth of field, and shoot straight up. This type of shot can be done successfully with midday light. The sun directly overhead will backlight all the yellow leaves and make their colors pop. After spending some time trying this technique, continue down the road to Cottonwood Lake, where aspen-covered hillsides throw golden colors into this pretty little body of water. A campground is here if you want to spend some time in this area.

Directions: From US 24 and the town of Buena Vista, go west on the Cottonwood Pass Road about 7 miles to the junction with Forest Road 344. Cottonwood Lake is 3 miles back.

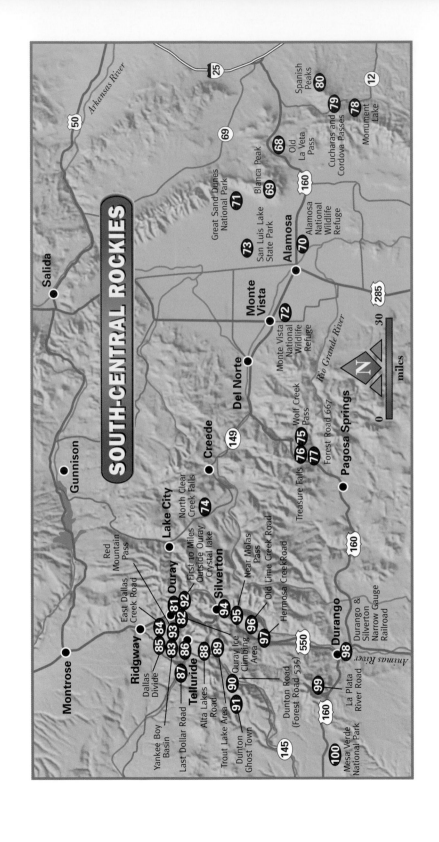

SOUTH-CENTRAL ROCKIES

IV. South-Central Rockies

US 160, Walsenburg to Pagosa Springs

General Description: The east end of this area, near Walsenburg, looks and feels like plains or even northern desert, but the Colorado Rockies are always in sight to the west and always beckoning photographers to explore in that direction. As you travel west from Walsenburg, the mountains rise quickly, then end just as quickly in the San Luis Valley, then rise again and keep going almost to the Utah border. This section of Colorado boasts a brand new national park, lots of snowcapped mountains rising above lakes and rivers, some excellent falling water, and a must-see wildlife spectacle.

Directions: All of the sites of this area are along US 160, an east/west route crossing southern Colorado. See site write-ups for additional directions.

Seasonal Influences: US 160 is the main route across southern Colorado and is open and maintained all year. The route crosses the Continental Divide at Wolf Creek Pass and this area gets tons of snow. Some storms force temporary closures of this pass or possible chain restrictions.

Old La Veta Pass (68)

La Veta Pass itself (also known as North La Veta Pass) is scenic and certainly worth checking out with your camera. Wide-open, flower-filled meadows and pretty aspen groves provide the subjects. The only problem with North La Veta Pass is that it is part of US 160 and traffic will be heavy and moving rapidly.

For those reasons I recommend that photographers in this area explore the Old La Veta

Where: South-central Colorado, part of US 160
DeLorme Gazetteer: Pages 78–82, 88
Noted For: Mountain scenery, fall color, wildlife, sand dunes, waterfalls
Best Times: March for wildlife, June for snow-capped peaks and waterfalls, late September for fall color
Accommodations and Services: Towns of Alamosa, Monte Vista, and Pagosa Springs; camping throughout the area
Diversions: Festivals in Alamosa and Monte Vista, soaking in the hot springs of Pagosa Springs

Pass Road. This great diversion route gets you off the highway and onto a road where moving at a snail's pace is encouraged. The road is sometimes dirt and sometimes paved but fine for passenger cars. Look for and shoot roadside flowers in spring and summer. There are lots of roadside pull-offs and places to leave your car as you wander the hillsides and meadows searching for shots.

Some of the old railroad buildings at the top of the pass can make interesting subjects. Use an old building as a foreground for your surrounding peak shots. The mountains look best with a covering of snow in spring and fall. Aspens grow thick on the west side of the pass; as with most of the Colorado Rockies, late September to early October is peak fall color time.

Directions: Coming from the east and traveling on US 160, exit at mile marker 281 off 160 and onto the Old La Veta Pass Road. The route joins back up with 160 after about 4 miles.

Blanca Peak

Blanca Peak (69)

As you drive along US 160 in this area, the dominant feature compelling you to stop and shoot is Blanca Peak. Of the four fourteeners in this southern section of the Sangre de Cristo Mountains, Blanca Peak is the highest at 14,345 feet.

You could stop for a photo anywhere along US 160 while Blanca Peak is in view. Development is scarce and you should be able to find a shot without buildings in your photo. During September the yellow rabbitbrush bushes make a great foreground.

For a reflection shot of Blanca Peak go to Smith Reservoir. This state wildlife area south of the town of Blanca provides one of my favorite Mount Blanca shots. In the morning when winds are calm, the mountains will reflect in the reservoir. Shoot from the south side and find some rocks or aquatic plants for a foreground. This shot is most impressive when Blanca Peak has some snow on it. Be prepared with a state parks pass and "habitat stamp" for Smith Reservoir.

Directions: Blanca Peak can be seen and photographed from all along the section of US 160

about 50 miles west of Walsenburg. Smith Reservoir is south of the town of Blanca. Take Road 12 to the south off US 160 and go 3 miles to the park's entrance.

Alamosa National Wildlife Refuge (70)

The Rio Grande flows through this 11,169-acre refuge, which is managed for migratory birds. The waters of the river are manipulated by refuge personnel to provide habitat for wildlife, which is plentiful here. Bird photographers will especially like this place. The scenery from the refuge is good too, with Mount Blanca forming the backdrop to river bends, channels, cattail marshes, and ponds. Scenic photos are best during late afternoon and evening.

Birds and other wildlife are best photographed right from your car while driving the auto tour route. The wildlife here doesn't view vehicles as a threat and will usually keep on do-

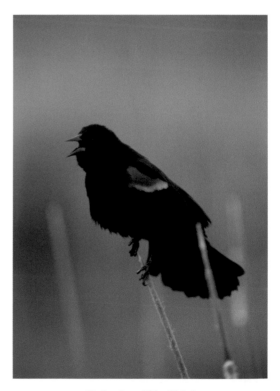

Red-winged blackbird

ing what they do; get out of your car, though, and everything will scatter. You'll need a long lens (500–600mm or more) and a window mount or bean bag for support. Drive at a snail's pace, use binoculars to spot subjects, and then creep the car forward until you can get your shot. I've seen and photographed owls, eagles, hawks, coyotes, waterfowl, and lots of songbirds very successfully from this refuge. Different seasons bring different birds; spring and winter are my favorite times. Spring migration brings songbirds and waterfowl to the refuge. Winter brings lots of geese and all the predators that feed on them.

Directions: From the town of Alamosa drive east on US 160 to El Rancho Lane and go south to the refuge entrance and the auto tour route. Be prepared to pay an entrance fee.

Great Sand Dunes National Park (71)

This is one of the best pattern-filled locations for picture-taking anywhere. To the amazing dunes add a snowcapped mountain range, colorful flowers, birds and other wildlife, and you get a five-star location.

Before sunrise, walk across the road from near the Pinyon Flats campground and get into the dunes. Find some animal tracks or wind-blown patterns to use as a foreground and wait for the sun to rise. Look for shots where the top of the dunes make great sweeping S-curves. Spend the middle of the day searching for flowers, photographing small birds and mammals at the campground, or, like professional photographers, getting in a good nap.

During late afternoon, drive the park road south and scope out a grand scenic location. Park along the wide-shouldered road and walk to the west—look for a shot that compresses the heavily sidelit dunes and the Sangre de Cristo Mountains. Stay and photograph this until the sun goes down. At sunset the dunes

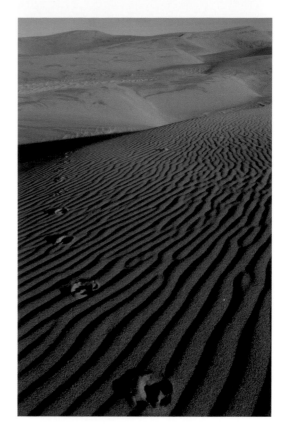

Coyote tracks on sand dunes

can glow orange, pink, or other shades depending on the sunset colors. Late August and most of September, when fields of sunflowers fill the meadows along the road, is the best time to be here.

Directions: From the town of Blanca, travel west on US 160 to CO 150 and go north to the park entrance.

Monte Vista National Wildlife Refuge (72)

This refuge is heavily manipulated to provide habitat for migratory birds, especially sandhill cranes. The artificial wetlands attract lots of birds every spring and fall, and with the right timing you'll find a bird bonanza. A variety of birds can be seen and photographed

throughout the year at Monte Vista, but by far the best time to be here is in March.

An annual crane festival, usually the second week of March, welcomes up to 20,000 sandhill cranes, a spectacle with excellent opportunities for photographers. As with all bird photography, you'll want and need the longest lens possible. A 500mm lens with a 2x teleconvertor is not too much here. Sunrise and sunset shots with silhouetted birds against a colorful sky are a good way to start the fun. Shots of flying birds against a deep blue Colorado sky are best shot later in the morning. Set up so that the sun is at your back and strong front light is on the flying birds. If you visit at other times of the year, look for waterfowl and songbirds. Use your vehicle as a moving blind with your camera and a long lens attached to a window mount or bean bag for support.

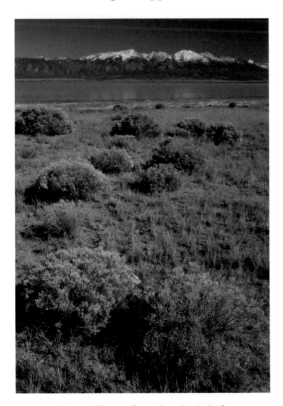

Mount Blanca from San Luis Lake

Directions: From the town of Monte Vista go south on CO 15 about 6 miles to the refuge auto tour route.

San Luis Lake State Park (73)

This small state park offers one of the best mountain reflection shots in the south-central Rockies. San Luis Lake provides the water and Blanca Peak and the Sangre de Cristo Mountains provide the background. All those mountains look especially scenic dusted with snow. The light will be best during the evening, so spend the afternoon finding a composition and hope for a calm atmosphere as you wait for sunset. My favorite month to visit is early September when the rabbitbrush is blooming. The yellow bushes make a great foreground.

Directions: From Alamosa take CO 17 north to road 6N LN and go east to the well-signed state park.

North Clear Creek Falls (74)

This is a great waterfall to see and photograph because it is impressive and atypical. The water plunges 60 feet over a volcanic edge and smashes into a group of black rocks below. The surrounding area is a cattle pasture and not particularly exciting, but your shots from here (if done right) will look wild and scenic.

A moderate telephoto is the best lens for North Clear Creek Falls. There are lots of compositional choices here and a zoom lens is handy to have. Zoom in a bit to eliminate the horizon, shoot horizontals with the falls offset to the left for a nice imbalance, or zoom way in on just the cascades toward the bottom of the falls. You definitely want to use a polarizing filter here. It slows down your shutter speed by two stops to create that silky look to the water and it eliminates distracting glare from the black rocks. Presumably I don't need to tell you to use your tripod. This is one of those rare falls that looks good in any light.

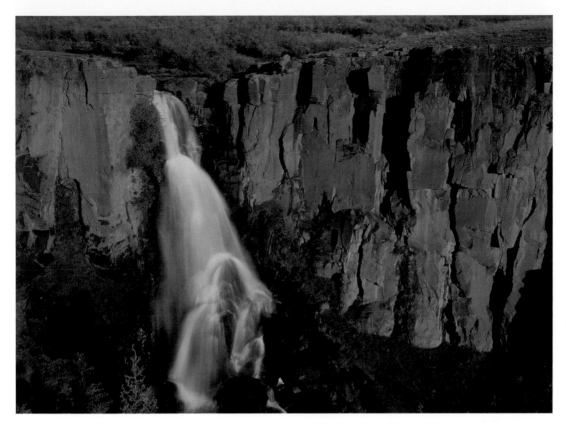

North Clear Creek Falls

Directions: From the small village of South Fork and US 160, travel north on CO 149 to about mile marker 49 and turn eastward on Forest Road 510. Take 510 to the well-signed parking area for the falls.

Wolf Creek Pass (75)

Wolf Creek Pass crosses the Continental Divide at 10,850 feet. The surrounding area is so scenic that a photographer could drive up here any time and get some decent images. However, if you time your visit properly, you'll get some outstanding images. Here are some ideas for a photo tour heading east to west on US 160.

The Big Meadows campground area off Forest Road 410 on the east side of the pass has some lovely stream scenes and a great little cascading waterfall with a wooden bridge over it. I'd stop here on my way up the pass, especially if the day is cloudy. Spend some time looking for flowers and shooting cascades, then head toward Wolf Creek Pass.

Just before the pass itself, turn in at Wolf Creek Ski Resort (which usually gets more snow than any other resort in Colorado). Wind your way around to the Alberta Park Reservoir for summer flowers and views of a pristine pine forest reflected in a pretty lake. In winter, the Alberta Park area becomes a free cross-country ski area (unfortunately the land is slated to be developed into a condo resort).

Back on US 160, the summer roadside flowers are profuse and should tempt photographers to pull over; just take one of the nearby

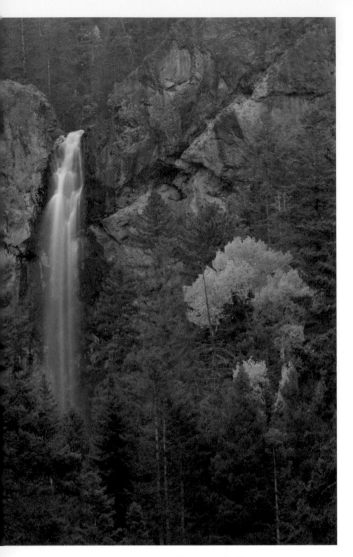

Treasure Falls

Treasure Falls (76)

This great Rockies waterfall is right off the highway, yet most people blast right by it and, despite the signs, don't even know it's there. Treasure Falls makes a single 105-foot drop over a cliff and disappears into a pine forest. Depending on the year's moisture, Treasure Falls can be an impressive mass of falling water or a thin wispy ribbon, barely visible. You can usually count on lots of water in spring when the snows are melting.

The angle of viewing right from the parking lot shows the falls and surrounding forest best. The falls actually disappears in the thick forest from almost any other spot. Mornings or cloudy days are the best shooting times and, as always, a tripod and polarizer are your friends around waterfalls—use them wisely.

Directions: Take US 160 about 15 miles northeast of Pagosa Springs to the well-signed turn-off on the east side of the road for Treasure Falls.

Forest Road 667 (77)

Forest Road 667 is north of Pagosa Springs. Also known as the East Fork Road, it starts out with a perfect farm scene and colorful cottonwood trees framing a pretty valley. Visit here in late September, when the cottonwood and aspen trees provide color galore. This winding dirt road (fine for passenger cars) curves through the trees and provides photographers with lots of chances to shoot. The road follows the East Fork of the San Juan River and comes to an end at a lush meadow below the Continental Divide. Particularly during midsummer, it's hard to imagine any place more abundant than this valley—flowers and insects and birds are everywhere.

Directions: To reach Forest Road 667, take US 160 east of Pagosa Springs about 10 miles to the East Fork Road and go east.

forest roads, which allow slow driving and safe stopping. Forest Road 402 or 725 are good choices. On the west side of the pass, after the second runaway truck ramp, is a marked scenic overlook that offers great views. This is a morning location and is especially good after a fresh early autumn snowfall.

Directions: Wolf Creek Pass is on US 160 northeast of Pagosa Springs.

Scenic Highway of Legends (CO 12)

General Description: This area, which is close to the border of New Mexico, has a lot to offer in a short distance. The designated scenic and historic route covers just 82 miles, but could take days for a curious photographer to complete. Ancient volcanoes, pretty lakes, mountain passes, farm scenes, and huge aspen forests are possible subjects. Come here any season and you'll find plenty of subjects to photograph, but very few people. If you want to photograph a place that never seems crowded, the Scenic Highway of Legends is it. Drive the main route, stop at the places I recommend, and explore others on your own. Take every side road your vehicle can handle, take lots of pictures, and enjoy.

Along Monument Lake Road

Where: South-central Colorado, part of CO 12
DeLorme Gazetteer: Pages 92–93
Noted For: Mountain scenery, fall color, and ranching scenes
Best Times: June for snowcapped peaks, late September for fall color
Accommodations and Services: Towns of La Veta, Cuchara, and Trinidad; camping throughout the area
Diversions: Hiking, fishing

Directions: The Scenic Highway of Legends starts in Trinidad where CO 12 intersects with I-25. The scenic highway runs west and then northwest from Trinidad and finishes in La Veta, just south of US 160.

Seasonal Influences: CO 12 is open and maintained all year. Winter storms can cause temporary closures.

Monument Lake (78)

Photographers will like stopping at this pretty little lake. A road encircles it and offers some decent views of the Spanish Peaks from the west and southwest sides of the lake. The peaks will be sidelit in late afternoon and the shadows create depth. You'll need my two-shot digital technique to manage the overall contrast between the foreground and background. Monument Lake is nestled in a valley, so sunrise and sunset are better viewed from somewhere else.

Directions: Monument Lake is 4.5 miles north of the tiny town of Stonewall, right off CO 12.

Cucharas and Cordova Passes (79)

Cucharas Pass sits at 9,941 feet and offers wide-open grassy-hill views to the north and south.

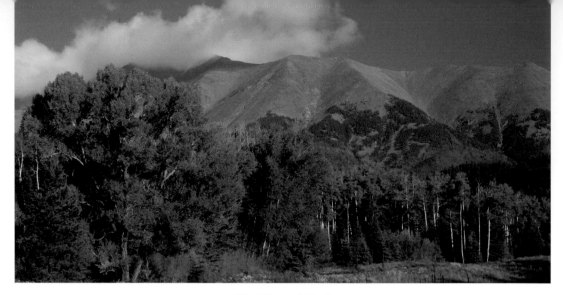

West Spanish Peak

Some aspen tree groves at the pass offer good color in early October. A photographer coming up here should head for Cordova Pass, though, which is accessed at Cucharas Pass. Cordova Pass takes you to one of the best places to shoot West Spanish Peak. Park at Cordova Pass itself and take the easy half-mile hike to Vista Point. Find a group of trees or flowers or an old snag for a foreground and be in this spot when late evening light hits the mountain and makes it glow red.

The area around Vista Point is a wide-open subalpine meadow and summer wildflowers grow abundantly here. Use a macro lens and shoot some flower portraits. Passenger cars are fine for the Cordova Pass Road.

Directions: Cucharas Pass is 4 miles south of the town of Cuchara on CO 12. Cordova Pass is accessed from Forest Road 415, which starts right at Cucharas Pass.

Spanish Peaks (80)

These two impressive mountains are the 20-million-year-old remains of an ancient volcano. Radiating from near the center of the peak are the Great Dikes of the Spanish Peaks. These are impressive rock fins that get as high as 100 feet and extend for as long as 14 miles. The fins make a great foreground for your shots of the Spanish Peaks. The best place to view and photograph both the dikes and the peaks themselves is from right along CO 12 from the town of Cuchara to the town of La Veta. Look for a place where one of the rock fins catches early or late light and use the fin as a leading line that heads toward one of the peaks. Much of the land around here is private property so ask permission to photograph before hiking around.

Another good place to see and photograph the Spanish Peaks is from the Cucharas Creek Recreation Area Road (Forest Road 422). This road follows Cucharas Creek on a curving path through a massive aspen forest, where photographers could spend all day. Prime time on this road is late September after some snow has blanketed the Spanish Peaks. This forest road is closed in winter.

Directions: Good views of the Great Dikes of the Spanish Peaks are from the section of CO 12 from La Veta to Cuchara. Forest Road 422 is 3 miles south of Cuchara off CO 12.

V. South-Western Rockies

Ouray to Telluride

General Description: This is probably the Colorado Rockies of your dreams. We're talking big jagged peaks covered in lots of snow, and rising above seemingly endless aspen and pine forests. We're talking mountains as far as the eye can see, and wild rushing rivers with crystal-clear water, and flower displays that boggle the mind. We're talking expanses of nature where wildlife still rules, mountain roads that slice high into the sky, and old mining towns where echoes of the past still linger. There are few places in the Colorado Rockies

> **Where:** South-western Colorado, reached by US 550 (Ouray) and CO 145 (Telluride)
> **DeLorme Gazetteer:** Pages 66, 76
> **Noted For:** Mountain scenery, fall color, wildflowers, and great mountain towns
> **Best Times:** July for wildflowers, late September to early October for fall color
> **Accommodations and Services:** Towns of Ouray, Ridgeway, and Telluride; camping throughout the area
> **Diversions:** Soaking in Ouray's hot springs, mine tours, skiing at Telluride, and festivals in the towns

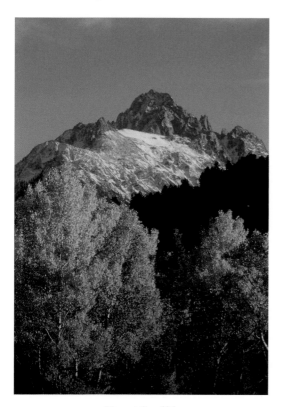

Mount Sneffels

that offer more quintessential "Rockies scenery" than this section from the town of Ouray to Telluride. Any season and any time of day, this part of Colorado is a great place to be a photographer!

Directions: The town of Ouray is some 95 miles south of I-70 on US 550. Telluride is southwest of Ouray, reached by a circuitous route of CO 62 and CO 145. See specific directions to individual sites listed in this section.

Seasonal Influences: This area, generally referred to as "the San Juans," gets walloped by snowfall every winter. Road crews do a good job of keeping the major roads open all year but storms can create temporary closures on some of the higher passes.

Town of Ouray (81)

Often referred to as the "Switzerland of America," the town of Ouray will certainly remind you of that mountain-filled country. Nestled

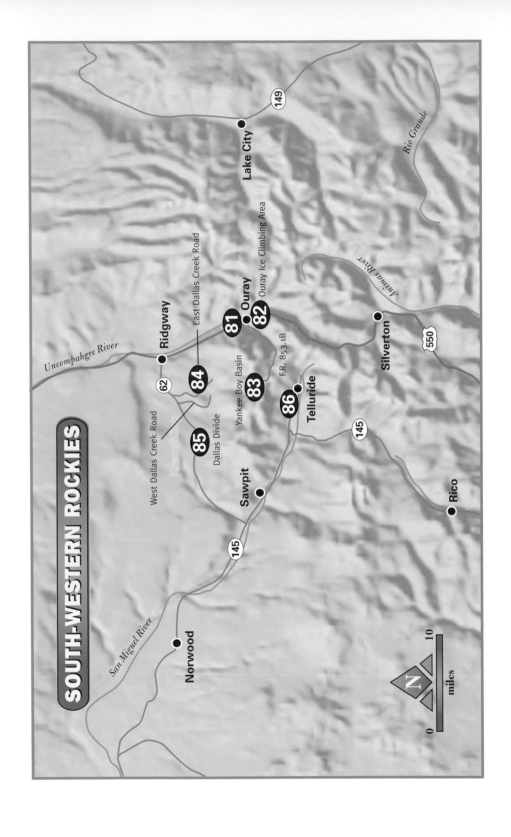

SOUTH-WESTERN ROCKIES

below towering peaks on all sides, Ouray is a mountain lover's paradise. Photographers will enjoy walking down the main street and doing some street shooting. Look for and shoot reflections of the surrounding mountains in shop windows. Look for Victorian architecture and interesting still-life shots of antiques in windows or hanging from shop walls. This is a wonderful walking town that also boasts a great hot springs to soak those weary feet after all that street shooting.

I recommend shooting an overall scenic view of this perfect Colorado mountain town from above it. Within the first mile south of town on US 550, stop at one of the wide pull-offs. Views from here can be especially effective during the holiday season when Christmas lights combine with fresh snow for a winter wonderland feel.

Directions: From I-70, take exit 37 to Business 70, and then go south on US 50; continue south on 50 until it turns into US 550 and continue south to Ouray.

Ouray Ice-Climbing Area (82)

Even if you never plan to strap on a pair of crampons and haul yourself up an ice wall with ice axes, you should come here for Colorado adventure sports photography at its best. The Ouray Ice Park is a steep, narrow natural canyon with huge ice walls made by piping in water along the rim and flowing it over the sides. Climbers in colorful gear work their way slowly up the giant icicles and ice cliffs. There is no fee to visit or use the ice climbing park and photographers can watch and shoot the action as long as they want.

Get good action shots from either of the canyon rims, shooting over at the other rim. I like wide-angle shots with one or two climbers coming up. These shots show just how big the ice walls are, because the climber provides a scale element. A small viewing platform on the

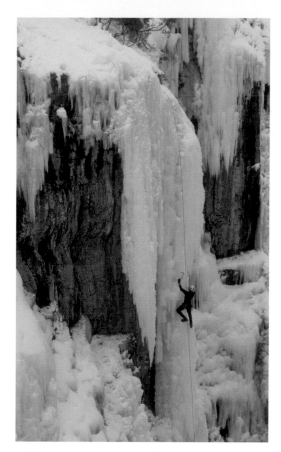

Ice climber

east rim juts out into the canyon just enough to provide the shooting angle you need. The canyon is so narrow and deep that direct light rarely gets to the bottom, so make sure you balance the light properly. If there is a blue sky overhead, film shooters should use a warming filter to cut out the blue, and digital shooters should be sure to use their camera's "shade" white balance.

The ice park is open from mid-December to March. A big ice climbing festival is held every year in mid-January (www.ourayicepark.com).

Directions: From Ouray go south on US 550 to Forest Road 853 (FR 853) and the well-signed Ouray Ice Park.

Yankee Boy Basin

Yankee Boy Basin (83)

This is the only site I've listed in this book where access requires more than a passenger car, but I just had to include the incomparably beautiful Yankee Boy Basin. Photographers should not miss this area. It is pure Colorado Rockies scenery and a five-star location if ever there was one.

The easiest way back here is to just drive yourself with a 4x4. A high-clearance vehicle minus the 4-wheel drive would also be OK, so long as the trail was dry. I have also seen regu-

lar passenger cars all the way to the basin (but this is dumb and dangerous and it is very costly to extricate your car if you get stuck back here, so don't do this and if you do, don't say I didn't warn you). Those with mere passenger cars can drive up to the point where a sign says 4x4 ONLY BEYOND THIS POINT, park here, and walk the remainder of the way on foot. You can also easily hire a jeep or take a guided jeep tour from one of the many offered in Ouray.

However you do it, just get yourself back to this basin. Early July is prime time to be here. Showy flower displays coupled with intense mountain scenery and gorgeous cascading waterfalls all come together to provide photographers with a heaven on earth. The classic shots from here are with a foreground of flowers (usually a group of blue columbines) and a snow-covered peak as background. This is a good place to practice hyperfocal focusing skills. (Hyperfocal means getting the maximum depth of field out of any given lens. Depth of field is the range of sharp focus.) You'll need and want all the depth of field you can get.

If it happens to be cloudy when you visit Yankee Boy Basin, shoot the waterfalls along Sneffels Creek and then plop yourself down in a field and work on flower portraits. The diversity of wildflowers in this basin will blow your mind and keep you photographing all day. The road to Yankee Boy Basin is closed in winter.

Directions: From Ouray, go south on US 550 to FR 853. Go southwest on 853 about 6.5 miles to the basin.

East Dallas Creek Road (84)

This is one of my all-time favorite back roads in Colorado and is so peaceful and uncrowded I hesitate to tell you about it. Here's what it has for photographers: awesome spring and fall scenery surrounding what I consider to be the most excellent mountain in all of Colorado.

Mount Sneffels is 14,150 feet high, a jagged peak usually covered in lots of snow.

Drive this route anytime in the summer for miles of green color provided by lush valleys and aspen trees. Then come back in late September and prepare to be blown away. At around mile marker 6 on the East Dallas Creek Road, the combination of golden aspens and views of Mount Sneffels should force you from your car. If the sky is blue, try this area when late afternoon light adds backlit magic to the aspens. Continue to the wide-open valley at about mile 7. Pull out a wide-angle lens and a polarizer and take in the beauty of this area. Shots are good right from the road but, if you hike around a bit, other possibilities emerge. Try the creek down below or the nearby aspen bole fence as foreground possibilities. East Dallas Creek Road has a dirt surface but is fine for passenger cars, all the way to its end at the Blue Lakes trailhead.

Directions: From the town of Ridgeway and US 550, go east on CO 62 about 5 miles to the East Dallas Creek Road (also known as County Road 7) and stay on it.

Dallas Divide (85)

This is a famous and oft-photographed location in the Colorado Rockies, and for good reason. The combination of wide-open views with lots of aspen trees and impressive mountains make it a scenic delight. The fact that you can drive right up to this awesome spot helps make it popular too. I'll suggest the obvious here and that is to use the aspen bole fence as a foreground. The way the fence heads downhill and makes a few bends as it disappears toward the mountains makes for a great photograph. Autumn is prime time here. The yellow aspens plus the snowy Sneffels range plus golden grasses and blue sky are pretty hard to beat. The first week of October is usually best. The

Dallas Divide road is open all year and winter is also scenic from here, especially with a fresh dusting of snow on the aspens.

Directions: From Ridgeway and US 550 go west on CO 62 to the well-signed Dallas Divide.

Town of Telluride (86)

When it comes to perfect Colorado Rockies towns, it's tough to beat Telluride. As the old real estate motto says, it's "location, location, location." The town is surrounded by national forest and wilderness areas with impressive mountain views no matter which way you turn. Photographic subjects in and around Telluride include a picture-perfect Main Street, Colorado's highest waterfall, and a magnificent ski area. Let's start with the town itself. Any season is good for walking down Main Street, people watching, and street shooting. The best shots of the town and its mountains are from the west side of Main Street looking east. Late afternoon and evening light is best.

At 365 feet high, Bridal Veil Falls is the highest waterfall in Colorado. You can do some

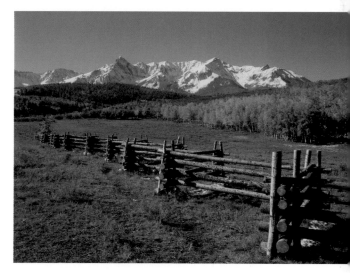

Dallas Divide

photography of the falls from the valley at the east end of Colorado Avenue (CO 145). Shots from here are of the distant falls. You'll need a long lens in the 200–400mm range to bring the falls closer. If you have a 4x4, you can drive up to the base of the falls; if not, it is a steep 1.8-mile hike to the base.

The ski resort at Telluride offers an un-crowded 1,700 acres of terrain. Photographers who ski will be thrilled by the impressive views of the San Juans from the top of the lifts. Those of you who don't ski can still get great shots from the ski resort and its surroundings. A free enclosed gondola runs most of the year (closed for several weeks for maintenance in April–May) and connects Telluride with the new Mountain Village. Take this great mode of transportation to access mountaintops, winter ski runs, and summer hiking trails.

One of the best ways to spend a summer afternoon and get some Rocky Mountains sunset shots is from the top of the gondola run. Ride to the top, spend some time shooting wildflowers in the meadows under the ski runs, then find yourself a sunset spot and shoot the setting sun. You'll have plenty of time to catch

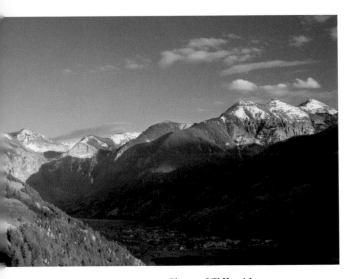

Town of Telluride

the gondola back to town—it runs daily from 7 AM until midnight.

Directions: Telluride is off CO 145 southeast of the junction with CO 62. Bridal Veil Falls can be seen from the east end of town where Colorado Avenue (Main Street) ends. To catch the free gondola go to Station Telluride at the corner of San Juan and Aspen on the south side of town.

Last Dollar Road (87)

I doubt that a back road can get any better than this for photographers. This forest road takes you to mountain scenes, summer flowers, and autumn aspens. Come here anytime (although it's not maintained in winter) and you had better bring double the film or digital memory that you think you'll need.

With a 4-wheel drive (in dry weather, just a high-clearance vehicle is required) you can take the Last Dollar Road all the way from Telluride to the Dallas Divide. Those of you without at least a high-clearance vehicle can still get safely down the Last Dollar Road from Telluride a good 8 miles or so.

Let's start in Telluride and see what this amazing route is all about. Just as you turn off CO 145 onto the Last Dollar Road, the shooting opportunities start with a great old grey barn in a lush field and Mount Wilson, in all its 14,000-foot glory, as a background. Shoot this scene with a moderate telephoto lens to compress these elements; it's best in morning light.

Continue up the road past some very pricey real estate and watch for panoramic views of the Lizard Head Wilderness looking across the Telluride airstrip. Up you go into one of the best fall color locations in all of Colorado. The Last Dollar Road winds its way through aspen forest after aspen forest, with S-curves galore. Use the dirt road as a subject here with golden aspen trees and fallen yellow leaves to accentuate the back road feel.

The road continues up and up until you'll be looking down on all those aspens with an entire mountain range in the background completing the sublime scene. Summer on this road can be beautiful with flowers in meadows and freshly greened aspen trees, but autumn simply can't be beat. The last week of September through the first week of October is prime time to be on this back road.

Directions: From Telluride, drive west on Main Street (West Colorado Avenue) to the junction with Forest Road 638, which you should take northwest as far as your vehicle will allow. A 4x4 vehicle that continues will eventually end up on CO 62 just 1 mile west of the Dallas Divide.

Alta Lakes Road (88)

In addition to the Last Dollar Road, this is another Uncompahgre National Forest road you should explore. Aspen forests and views of snowcapped peaks are primary subjects. This road also goes by a ghost town where some good images can be made.

While passenger cars can make it all the way to the Alta Lakes on this road, you'll want at least a high-clearance vehicle, and a 4x4 would make even more sense if the road is wet.

Start off by shooting autumn aspen forest scenes where dropped leaves carpet the dirt lane. Eventually some meadows come into view where the craggy Ophir Needles can be seen to the south, a tight group of bare rock pinnacles that slice into the sky above the trees.

Frame up a shot with the Ophir Needles catching either morning or evening light. Use the strong side lighting at those times to your advantage.

Continuing up the road you'll come to Alta Ghost Town. This place had a population of 100 residents during the gold rush. Some of the original buildings are still standing. Most of this area is privately owned so ask permis-

Mount Wilson from Alta Ghost Town

sion to photograph at the modern house before poking around.

At the end of the road, the Alta Lakes provide great scenic views. Shoot a panoramic composition here. A panoramic consists of several shots that you'll stitch together later with a computer. Remove your polarizer for panoramics as the filter will not affect the sky uniformly across the range of a panoramic scene.

Directions: Go south of Telluride on CO 145, just past Cushman Lake to Forest Road 632, which is signed for Alta Lakes.

Trout Lake Area (89)

This natural lake and nearby Lizard Head Pass and Peak should give you plenty of reasons to drive south of Telluride looking for images. At Trout Lake, several 13,000-foot peaks dominate the views. Wander the shoreline looking for shots. Find something of interest on shore to use as a foreground for wide-angle shots of the lake and the peaks. If you are lucky enough to have calm water and are here during the evening, all those mountains will reflect perfectly in Trout Lake.

Back on the highway, drive south to Lizard

Head Pass, where wide-open meadows have lots of summer flowers and the background for your camera is still those impressive San Juan Peaks. Drive south of the pass until you see Lizard Head Peak—a 13,000-foot peak with a massive spirelike rock top. A field of flowers, some low-lying clouds, or the small nearby curving stream all make for a good addition to your shots of this mountain.

Directions: Take CO 145 south of Telluride about 10 miles to Trout Lake and an additional 2 miles to Lizard Head Pass.

Dunton Road (Forest Road 535) (90)

This graded dirt road travels for 32 scenic miles through the San Juan National Forest. Don't miss this route, but don't tell anyone about it, since it currently has very little traffic

Trout Lake

and even fewer photographers. The road starts south of Lizard Head Pass, off CO 145, travels along several scenic streams and rivers, and ends back at CO 145 north of the town of Dolores. Passenger cars can drive the entire route with no problem. The road is open all year but just can't be beat during peak fall color time, usually the first week of October.

Let's start on the east side. Watch for the views of two fourteeners, Mount Wilson and El Diente Peak, at the junction of Dunton Road and Forest Road 471. Frame up these high peaks with a lone group of aspens, or use a golden field as foreground. Continue traveling west, and you'll pass through stand after stand of aspen trees with the dirt lane curving through.

At about the 9-mile marker you'll pass Dunton Ghost Town where you'll definitely want to spend some time. Back on the road, you'll follow the West Dolores River and the scenic splendor continues. Wide-open valleys flanked by golden aspen trees should inspire anyone with a camera to slow down, stop, and shoot like mad. Try finding a hillside of aspens with just one or two dark green coniferous trees to offset all that yellow.

Eventually you'll come to some farmhouses and bucolic scenes straight out of a Norman Rockwell painting and lots more aspens for color galore. The last 13 miles or so heading west are paved but no less spectacular, with more aspens covering both sides of the Dolores River Canyon.

Directions: Take CO 145 about 5 miles south of Lizard Head Pass to the well-signed Dunton Road (Forest Road 535).

Dunton Ghost Town (91)

This is without a doubt the best ghost town in Colorado. From a distance it looks like a perfect little 1880s town complete with worn buildings and rusted machinery. However,

Dunton Ghost Town

looks can be deceiving. Currently it is a luxurious resort, Dunton Hot Springs, catering to the $250-to-$425-a-person-a-night crowd. Treat yourself to an all-inclusive Colorado Rockies getaway here someday after you win the lottery. Until then, you can still photograph the ghost-town-turned-resort for nothing.

I've stopped by Dunton several times and even though I wasn't a guest, I was treated with the utmost respect and courtesy. Each time, I was allowed to wander the town and photograph anything I wanted. I asked the management about mentioning this place in this book for photographers and they kindly told me that as long as no special functions were happening, you'd get the same nice treatment as I did. Just announce yourself at the gated bridge intercom and bring lots of film or digital memory.

Every building has been painstakingly renovated on the inside, while the outside retains the original 1880s look and feel. Shoot the buildings by themselves and as secondary subjects for wide-angle scenics. The antiques hanging around make great close-up shots. The grounds of the former mining town are kept in a natural state with summer wildflowers growing everywhere and fall-colored aspens creating dazzling displays in late September. Visit in the winter for a completely different sort of Colorado getaway: peace and quiet like you've never dreamed.

Even though this is private property, photographers are welcome to visit and shoot, so let's respect this place and the folks who run it so that they remain friendly to those of us carrying big cameras and tripods in the future. (Now if only I can get a complimentary night for saying such nice things about Dunton!)

Directions: From CO 145 south of Lizard Head Pass, go west on Forest Road 535 for 9 miles to the ghost town/resort entrance.

US 550, Ouray to Durango

General Description: If there is one scenic drive in the Colorado Rockies that best showcases mountain scenery, this is it. The northern part of this drive, from Ouray to Silverton, is known as the "Million Dollar Highway." The reason for that moniker is still disputed and I offer here another one: the views along this section are worth a million dollars! The rest of the route on down to Durango also has extensive, knock-your-socks-off views. This route is so great photographically that it could take you a while to get anywhere. Use the numerous pull-offs and roadside parking areas to stop and explore with your camera. The Colorado Rockies just don't get any better than this.

Near Crystal Lake

Where: South-western Colorado, reached by US 550
DeLorme Gazetteer: Pages 76, 86
Noted For: Mountain scenery, fall color, and great mountain towns
Best Times: June for fresh green color on aspens, late September and early October for fall color, and January and February for deep winter snows
Accommodations and Services: Towns of Ouray, Silverton, and Durango; camping throughout the area
Diversions: Hiking, mine tours, and festivals in the towns

Directions: This section starts in Ouray, 95 miles south of I-70 on US 550 and continues on 550 all the way to Durango. See specific directions to individual sites listed in this section.

Seasonal Influences: US 550 is the major north/south highway in this part of Colorado and as such is maintained all year long. This area gets lots of snow each winter and strong storms will temporarily close 550, or create travel restrictions. Drive this route slowly, as the road can be slippery at any time and guardrails aren't always there to keep you from plunging off a steep cliff.

First 10 Miles Outside Ouray/Crystal Lake (92)

As you head out of Ouray and start switchbacking up toward Red Mountain Pass, the scenery is supreme and you should stop at every pull-off and explore photographic possibilities. A couple of cascading creeks are worth exploring and the abundant aspen trees look great in late September. The mile markers are

Red Mountain Pass

in descending order as you travel south from Ouray toward Silverton and Durango. At mile marker 88 is one of the best aspen curves on this stretch. During autumn, the colorful trees blanketing both sides of the highway will almost beg you to stop and shoot. Small stands of conifers are mixed in here and there, and make for a great secondary subject to all that yellow. Continue up to mile marker 87, which is Crystal Lake. On either side of the highway are miles and miles of aspens. Park here and explore the area. Shooting possibilities include aspens and the Red Mountains reflected in Crystal Lake, trails meandering through aspen groves, and wide-angle scenes of lake and aspens and mountains. The Hayden trailhead traverses the lake and is an easy hike. Summer flowers are good here as well.

Directions: From Ouray, travel south on US 550, watching for highway pull-offs and parking areas.

Red Mountain Pass (93)

Red Mountain Pass sits at 11,018 feet. Any pass over 10,000 feet is good and high, even by Colorado standards. Mountains surround this pass and actually hem it in a bit on the north side so that the best views and photos from here are smaller scenes rather than big horizon-to-horizon views. Several small alpine lakes present themselves just north of the pass. Stop here for possible reflection shots of Red Mountain in the ponds and for displays of summer flowers. Mid-July up here is usually good timing for a wildflower spectacle, with dozens of species blooming in profusion.

Park at Red Mountain Pass itself and explore the wide-open views to the south. Find some summer flowers for a foreground to your mountain shots and practice your hyperfocal focusing and shooting techniques.

Directions: Red Mountain Pass is right on US 550 about 13 miles south of Ouray.

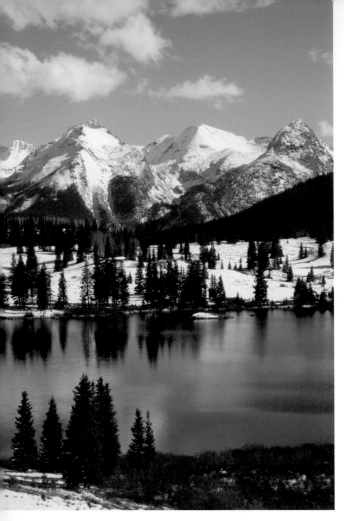

Molas Lake

Town of Silverton (94)

Silverton is one of my favorite Rocky Mountain towns. Its utter isolation in the Animas River Valley, surrounded by high mountain peaks, certainly appeals to my need to escape from urban sprawl. When you're in Silverton, you could convince yourself that you're a million miles away from it all.

Photographically, Silverton has much to offer, and I'd start with the 19th-century charm of many of the residences. Silverton proudly calls itself a Victorian mining town, and it still has its frontier flair. The dirt streets and false-fronted buildings make for great old-time shots. In summer, lots of tourists stop here and the locals show off their roots. Horse-drawn wagons, staged gun fights, festivals, brass bands, and parades are all possible photo subjects.

Reasons to visit in winter include holiday lighting festivals, dogsled races, and snowmobile events. The main reason, of course, is the wonderful mountain scenery, especially along County Road 110, which heads north and northeast out of Silverton. This is also a good route to travel while looking for summer wildflowers. If you have a 4x4, try Forest Road 4 (FR 4) and then Forest Road 3 out of Howardsville to Stony Pass for flower displays.

One of the best overall shots of Silverton itself can be taken from a large pull-off on US 550. Look for an opening in the trees about 1.5 to 2 miles south of town for a view of Silverton twinkling below those massive mountains and looking so much like a miniature town in a toy train set. Silverton is of course the northern end point of the Durango & Silverton Narrow Gauge Railroad.

Directions: Silverton is just off U S 550 about 25 miles south of Ouray and 42 miles north of Durango. County Road 110 is Main Street in Silverton. Take it through town and then either north or northeast for scenic views. Northeast on 110 will take you to Howardsville and FR 4.

Near Molas Pass (95)

As you are traveling south on US 550 away from Silverton, you'll begin to see some huge panoramic views, mainly to the east, near mile marker 67. Find a safe pull-off area and stop the car. Compose a multi-shot panoramic of the scene in front of you. Afternoon light is best.

Continue up the road to Molas Lake. This lake and the park that surrounds it are owned and managed by the city of Silverton. During

the summer (closed in winter) Molas Lake Park is a Rocky Mountain dream location. High jagged peaks rise above a crystal-clear lake and pristine pine forests stretch in all directions. The park has a campground if you want to spend some time here—and you definitely want to. Photographers should explore every bit of this park and shoot at least one sunrise and one sunset here.

For early morning light, go around Molas Lake to near camping sites 53–60 and compose shots of the lake and the mountains of the San Juan National Forest. Evening light is best from the west side of the lake around camping sites 1–5. This area is a good bet for a reflection shot. When the sun is low on the western horizon, the peaks of the Grenadier Range will glow, and they'll be mirrored in a calm Molas Lake. Emphasize the sky if you've got an interesting one and emphasize the foreground if nothing's happening in the sky.

Directions: Molas Lake is just off US 550 about 5 miles south of Silverton.

Old Lime Creek Road (96)
This is a side road off US 550 that absolutely, positively should not be missed, especially sometime in late September or early October. This curving dirt lane through aspen grove after aspen grove provides supreme fall color possibilities. You might even want to come back and drive the route again the next day, and hope for different light. I prefer a cloudy day for this scenic route, but any light is actually good here. Let's start from the north end and travel south.

Exit US 550 onto Forest Road 591 (Old Lime Creek Road). A passenger car is fine on the northern section but in order to drive the entire route without any worries, use a high-clearance vehicle. A 4x4 is required when conditions are wet or muddy. Within the first mile

on the northern part of Old Lime Creek Road, the summer flowers are profuse and the autumn aspens provide plenty of shots. Continue, looking for those wonderful curving dirt lane shots with yellow aspen trees and fallen leaves blanketing the road. Steep hillsides of aspens to the east are along the entire route. Snap on a moderate to long telephoto lens and pick out textures and patterns that interest you. A polarizer improves foliage shots. The filter

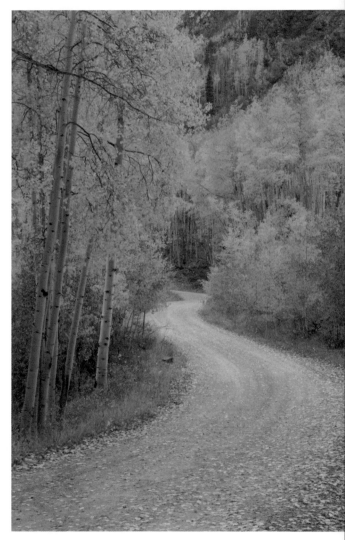

Old Lime Creek Road

makes the colors pop by removing the white-light glare reflected by every leaf.

The road continues, following Old Lime Creek, which is sometimes far below. Eventually the road gets down to creek level where the crystal-clear water makes a great foreground for scenic shots. Continuing south, the road climbs higher and higher above the creek until it is just a ribbon of waterway below. The aspen hillsides are really great now, with unlim-

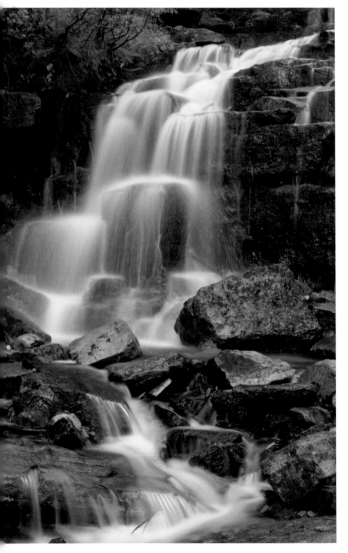

Relay Creek

ited potential for those texture shots. More curves, summer flowers, and mountain views make up the southern section of Old Lime Creek Road. Eventually the road ends back at US 550.

Directions: Take the well-signed Old Lime Creek Road exit off US 550, about 3.5 miles south of Molas Pass.

Hermosa Creek Road (97)

This forest road (578) starts right at Durango Mountain Resort (a source of skiing shots in winter) and makes a nice summer getaway. Lots of roadside flowers, aspen trees, cascading creeks, and mountain views all await you on this road. Some aspen tree groves provide good fall color but summer is the prime time to drive this way.

Passenger cars are fine on this road. Drive slowly and stop at any of the lush meadows you encounter. Get out with a macro lens attached to your camera and explore all the close-up possibilities you can. The entire route travels parallel to the east fork of Hermosa Creek, which is decent for cascading water shots, but several other creeks along this way are better. My favorite is the third one you'll encounter, Relay Creek. This small stream is worth a couple hours of exploring for small waterfalls and countless cascades. Remember that whenever shooting around water of any type, try your polarizing filter and see if it improves your shots (usually it does). If you have a choice, visit this site on a cloudy day. Contrast for flowers and all those water shots is greatly reduced (and thus improved) on a cloudy day.

Directions: From the entrance to Durango Mountain Resort continue west on Hermosa Creek Road (Forest Road 578). Explore the route until the road becomes too rough for your vehicle.

Durango Area

General Description: Durango is big enough to offer lots of excitement and small enough so that you don't feel like you're caught in an urban mess when you're here. The area boasts access to the San Juan National Forest at every turn, endless outdoor activities, one of the top national parks in the country, and enough photographic potential to last a lifetime. Any season is a good time to visit the Durango area. Spring and summer mean sunny days, hiking the national forest, boating and fishing on the area's rivers and lakes, and lots of flowers and outdoor sports as photo subjects. Fall is when this area turns gold. More sunny days and more aspen trees than you can believe will fill your viewfinder during autumn. Winter storms dump tons of snow and then move off, leaving everything white-laced and splendidly photogenic.

Directions: Durango is in the southwest corner of Colorado, about 68 miles south of Ouray and just 20 miles north of the New Mexico border.

Seasonal Influences: Most of the sites listed in this area stay open year-round. Durango sits at the junction of two major U.S. highways and road crews are pretty good at clearing the roads

Aspen leaves in autumn

Where: South-western Colorado, reached by US 550 or US 160
DeLorme Gazetteer: Pages 85–86
Noted For: Mountain scenery, fall color, narrow gauge railroad, and Native American cliff dwellings
Best Times: Early October for fall color, April and May for mild weather at Mesa Verde, and February for snow with blue skies
Accommodations and Services: Towns of Durango and Corez, camping throughout the area
Diversions: Whitewater rafting, hiking, and fishing

after a winter storm. See individual site write-ups for additional closure information.

Durango & Silverton Narrow Gauge Railroad (98)

You can photograph this train, whether you're a passenger or not, as it pulls into or out of either the Durango or the Silverton station. The background scenery is better elsewhere, however. My favorite spot for getting shots of the train (when you're not riding it) is from the town of Rockwood. Leave your car in this tiny town and walk south on the narrow gauge tracks to a spot where the train comes around a bend. As it puffs its way up the hill, giant steam clouds rise into the sky and make your shots look like something out of the Old West. Check the train schedule before setting up here so that you'll know when the train is due (www.durangotrain.com/about/schedule.htm).

For photographers as well as train buffs, nothing beats a ride on the Durango & Silverton Narrow Gauge Railroad. Trains run at least daily throughout the year. Winter trains run from Durango to Cascade Canyon and back,

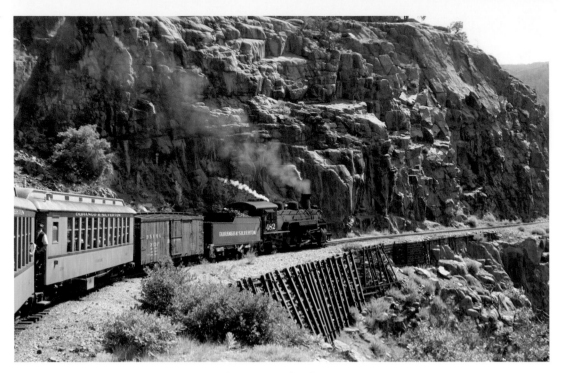

From the Durango & Silverton train

summer trains from Durango to Silverton and back. In either season the scenery along the route is breathtaking. Of course, as a passenger, you'll be moving the entire time—the train won't stop for you to set up a tripod and shoot the scenery. So, take this trip to see the scenery and to shoot the train itself as it winds through the mountains. The best train shots are from cars in the back of the train looking forward at the chugging engine. The plume of exhaust steam makes shots look antique, so be sure to emphasize that. Use as fast a shutter speed as possible to negate any motion. Raise your digital ISO or push your film a stop if necessary.

The train is also a great way to access the Weminuche Wilderness. Along the route the train will stop at Needleton, where a primitive campground and hiking and backpacking opportunities await. Needleton would be a great place to bring a backpack of gear, camp out, and get lots of photos of summer trains as they pass by.

Directions: The Durango train station is at 479 Main Avenue near the corner of US 160 and US 550. To get to Rockwood, take US 550 north out of Durango for about 16 miles to Forest Road 745 and go east to the small town. Park and walk the tracks south to where the train tracks sweep around a bend, and shoot from here.

La Plata River Road (99)

This forest road provides good access to the San Juan National Forest. The first 3 miles of the road offer views of the snowcapped La Plata Mountains. Find a foreground of colorful aspen trees or use the La Plata River for that. Try this area in the springtime when the aspens have fresh green leaves on them and the peaks are still snow covered.

Continuing up the dirt road, watch for and shoot any of the creeks that flow into the La Plata River along the way. My favorite is Bedrock Creek. A very pretty falls just off the road presents itself right where Bedrock Creek flows into the La Plata River. This cascade is best later in the season, when less flow makes the soft cascade even more delicate. Use a tripod and long shutter speed to show the flow of the water.

Passenger cars will do fine on the road for about 8 miles up the La Plata River Road. After that you should have a high-clearance vehicle. In those first 8 miles are some excellent aspen stands and what I consider to be a cloudy day heaven—curving dirt lanes carpeted with fallen aspen leaves. Remember to use your polarizer to cut out the white light reflecting off every leaf.

Directions: From Durango go west on US 160 about 10 miles to the La Plata River Road (Forest Road 124) and go north on it.

Mesa Verde National Park (100)

There are two important things I have to tell you about this park. First, technically it isn't in the Colorado Rockies; it sits on a high plateau in extreme southwestern Colorado. However, it is such a fascinating place that I just had to include it in this book. Second, this unique place is so intriguing that I certainly won't be able to do more than touch on the highlights of the photographic opportunities Mesa Verde offers.

Come here to see and photograph the best Native American cliff dwellings and examples of ancient architectural mastery in all of North America. Mesa Verde offers photographers an unequaled array of sites and experiences. The two main dwelling areas are Chapin and Wetherill Mesas. Since Wetherill Mesa is remote and open only in summer, I'll concentrate on the photo spots at Chapin Mesa. (Still, I recommend you explore Wetherill Mesa; you'll just have to do it without my help.)

Chapin Mesa contains three major cliff dwellings, including the largest in the park, Cliff Palace. Photographers should shoot from the overlooks and also take a ranger-guided tour into one of the dwellings. One of my favorite overlook spots for photos includes late afternoon and evening light at Square Tower House. Use a moderate zoom lens to crop out all extraneous stuff from your photo of the tallest structure in the park. This overlook is on the western loop drive of Chapin Mesa. Other ruins on this drive include Sunset House, New Fire House, and Oak Tree House. All of these are lesser structures that you'll be photographing from across the way. A longer zoom lens in the 200–400mm range is required to bring the details of these houses closer.

Aspen trees

Afternoon or evening light is best for all these dwellings.

On this same loop drive is the best vantage point for shots of Cliff Palace. You'll be looking down onto an archaeological wonder that's over 800 years old. Over 200 rooms, some with round towers, and some three stories high, will provide enough subject matter to keep you busy for quite some time. Try to shoot the scene a variety of ways. Use a 300–400mm lens and pick out details in the architecture. Use a wide-angle lens and part of the curving canyon lip right in front of you for foreground. Show the scene with and without people wandering around the palace.

A ranger-led tour is the only way to get into any of the dwellings. It is well worth doing, even for photographers who hate such cattle calls. My recommendations include touring at Balcony House—but be sure to carry your camera in something that leaves your hands free as you'll be climbing ladders and some very steep steps. Leave your tripod behind for all tours. I also highly recommend that you take the last tour offered in the afternoon to Cliff Palace. The light is warm and gorgeous at this time. I always stick to the back of the group and let everyone else move on if I want a people-free shot. The rangers usually give you a minute or so before herding you forward. This is a photo opportunity not to be missed. These ranger tours are not available in the winter; Spruce Tree House does have guided tours in the winter and self-guided tours the rest of the year.

Mesa Verde is full of wonders to see and photograph. Any season can be good. However, spring and summer brings the largest crowds, and shots without people may be hard to come by. This place is also brutally hot in summer. Fall offers nicer weather, fewer people, and good light. Winter is a challenge, but could be worth the effort—you may even have the park to yourself in winter. Very few if any park services are open in winter, though, and the temperatures can be painfully cold. Still, the dwellings with a fresh dusting of snow on them are spectacular.

Directions: Mesa Verde is 36 miles west of Durango. Take US 160 west from Durango to the park entrance. From the visitor center, go south to Chapin Mesa and drive all the loop roads looking for photo opportunities.

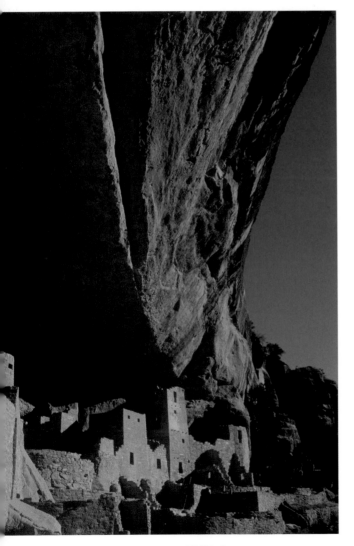

Cliff Palace